Devon

OFF THE BEATEN TRACK

Other Devon titles available from Countryside Books include:

Devon

OFF THE BEATEN TRACK
Tricia Gerrish

With illustrations by
Angela Brown

COUNTRYSIDE BOOKS
NEWBURY BERKSHIRE

COUNTRYSIDE BOOKS
3 Catherine Road
Newbury, Berkshire

To view our complete range of books,
please visit us at
www.countrysidebooks.co.uk

ISBN 1 85306 749 0

For my godmother Pamela Janet (Babs) whose father was a Devon lad

Cover design by Nautilus Design (UK) Ltd
Front cover photograph showing Slapton Sands supplied by
Bill Meadows.
Back cover photograph of the clock at St Mary Steps church,
Exeter, supplied by the author.

Produced through MRM Associates Ltd., Reading
Typeset by Mac Style Ltd, Scarborough, N. Yorkshire
Printed by J. W. Arrowsmith Ltd., Bristol

INTRODUCTION

'Old England's counties by the sea
From East to West are seven,
But the gem of that fair galaxy
Is Devon, is Devon, glorious Devon'.

(Traditional song)

It was a delight to be asked to uncover some of the fascinating facets of Devon. Accompanied by my 'other half' who acted as driver – leaving me free to navigate – I was amazed at how, after so many years of travelling its highways and byways, there are still things about the place that take me by surprise.

Was Devon so well endowed with leper hospitals because of its maritime history? There was a total of eleven in the county before 1350. I found buildings incorporating three, plus reference to the location of a fourth at Totnes, near the leech wells. Amazingly, at Taddiport in Great Torrington, field strips worked by lazars have been preserved into the 21st century. And who defaced the church rood screens at Ashton and Manaton; white-painted the faces of saints in Pilton; vandalised a rood loft in Sherford church and the entire screen at Lew Trenchard? Dip into these pages and find out.

In a North Devon estuary-side village you can wait on a platform for the train which will never arrive; or outside a thatched pavilion, watch batsmen hit sixes to be recorded on a thatched cricket scoreboard.

To those places whose unsung gems have had to be omitted from this book, my apologies. With so many miles of coastline and high-banked Devon lanes to explore and a plethora of features both man-made and natural from which to choose, it was inevitable that there would not be enough space to include everything.

I would like to thank all those patient Devonians, however, who have answered my questions; to West Country Studies Library staff; and to Lynette, of Exmouth Library's reference section for tracking down elusive information.

I hope Angela Brown's lovely drawings and at least some of the stories behind Devon's hidden delights capture your imagination and encourage you to get off the beaten track and explore this beautiful county of ours.

Tricia Gerrish

BENNETS CROSS

DEVON

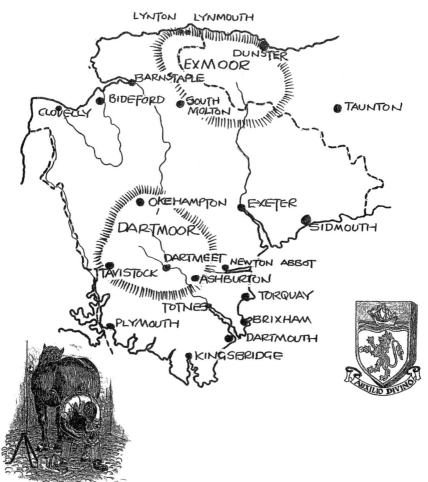

LYNTON LYNMOUTH

DUNSTER

EXMOOR

BARNSTAPLE

BIDEFORD ● SOUTH MOLTON

CLOVELLY

● TAUNTON

● OKEHAMPTON ● EXETER

DARTMOOR

● SIDMOUTH

DARTMEET NEWTON ABBOT

TAVISTOCK ● ASHBURTON

● TORQUAY

TOTNES ● BRIXHAM

● PLYMOUTH ● DARTMOUTH

● KINGSBRIDGE

AUXILIO DIVINO

APPLEDORE

The Danes attacked Devon's coastline in several places; over the last two centuries re-enactments of these events have been numerous. Their invasion and landing near Appledore reflects in the street name Odun Street – where you find the village's Maritime Museum in a former merchant's house. It's impossible to mistake; there's a large female figurehead over the porch.

Appledore still has a shipyard; its lifeblood has been the meeting point of rivers Taw and Torridge, flowing over the bar into Bideford Bay. Replicas of old sailing boats as well as gas container ships have all been built here recently. Its history embraces the steep, narrow streets and passageways of a 'free port' granted by Queen Elizabeth I for its part in the Armada of 1588, and involvement in the tobacco trade and with Canada. Today it attracts holiday visitors, offering fishing and other boat trips from Thomas Carter's Quay of 1840, somewhat altered from when he created it from a clutter of jetties and wharves at the end of gardens.

Those Danes moved rapidly inland in AD 878 – led by Hubba, Earl of Frision, who had been plundering in South Wales – into the parish of Northam, which included Appledore. They engaged battle with Odun, Earl of Devon and, according to legend, with King Alfred the Great. Arx Cynuit is the name given to the area where Odun routed Hubba and killed 800 of his men: a name which has given historians plenty to argue over. Kinwith (later Kenwith) Castle near Abbotsham is a likely possibility for its location, but, as you go round Bloody Corner south of Appledore (OS 455292), a tablet placed here c1890 indicates otherwise: 'Stop stranger stop, on this spot lies buried King Hubba the Dane, who was slain by King Alfred the Great, in a bloody retreat'. Authority for this comes from no less than the *Saxon Chronicle*.

It seems pretty certain that Hubba's body found its way back to Appledore for burial under a pile of stones on the shoreline as was his country's custom. Before the Second World War there was a large stone on Appledore waterfront known as Hubba Stone – and a Hubbastone Road.

ASHBURTON

A Sioux Indian war bonnet and beaded moccasins are hardly what you'd expect to find in a small town in South Dartmoor, but they're here in Ashburton' s little museum. This historic stannary town, named from the Ashburn stream on which it stands, has lots to offer. Here Dartmoor tin was weighed and assayed from the late 13th century; cloth also played a large part in its fortunes.

Being at the meeting place of several routes with four bridges ensured Ashburton's position as a market town, with an early fairs charter. And, talking of bridges – under Kings Bridge where you enter the town's car park, children who were too adventurous were warned to look out for the evil water sprite Cutty Dyer: 'Don't 'ee go down to the riverside, Cutty Dyer doth abide. Cutty Dyer ain't no good, Cutty Dyer drink yer blood'.

Ashburton's former market house is today's town hall. An even earlier market house, resembling an upturned boat, sits in model form inside No 1 West Street, a Grade II listed building in which Ashburton Museum has settled. Beginning in a private house, the collection also occupied St Lawrence Chapel's tower room and a former blacksmith's shop on the site of Ashburton's ancient Grammar School before arriving at its present home. St Lawrence Chapel, given to Ashburton by Bishop Stapledon of Exeter in 1314, became part of the town's grammar school and is still home to ancient Courts Leet and Baron for the town.

The story behind acquisition of an almost unrivalled collection of North American Indian artefacts (in Great Britain) features Frank Charles Endacott. Born here in 1871 and educated at Ashburton Grammar School, Endacott emigrated to the United States of America. The museum displays a scholarship honours board of the 1880s and 1890s in which members of Frank's family feature.

Frank's son Paul visited his father's old home town from Bartlesville, Oklahoma in 1960. He offered its fledgling museum the American-Indian collection, plus money to provide showcases, in memory of his father. The Endacott generosity has continued.

Among the collection's highlights are a saddle from Winnebado Indians, a typical Cheyenne Plainswoman's dress, Crowe burial moccasins – and a travelling case for that war bonnet. Making such a head-dress was only possible with the

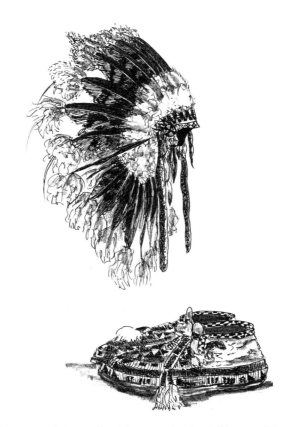

Sioux war bonnet and Crowe burial moccasins in Ashburton Museum.

consent of a tribe's warriors. It stood as a record of tribal valour, besides acknowledging a particular brave's distinction. Song and ceremony accompanied its creation; a war honour would be chanted for each eagle feather put into position.

Almost exotic enough to put Ashburton's beautiful setting in South Dartmoor into the shade – but not quite.

ASHTON

Ashton, on the western slopes of Haldon, not far from Exeter, is really two villages: Lower, and Higher – usually just called Ashton. At the lower end are the Manor Inn, a post office and stores and several cottages; a short drive upwards brings

you to more cottages, the village hall which has a useful car park and St John the Baptist church.

Ashton's Domesday manor was at Place Barton, west of the church: a manor given to Hervius de Helion. The church we see today came later – it is a late 14th–early 15th century structure, built on a rocky outcrop, with square tower of local sandstone and granite.

This is truly an 'atmospheric village church' to quote Devon historian W. G. Hoskins. Beer stone columns rise along its nave, leading the eyes past a 17th century pulpit with sounding board and iron hourglass stand to its most striking features – the screens. They really are splendid, being medieval, albeit several times restored; a doorway on the south side which gave access to the top of the rood screen to dress it according to the church's festivals can still be seen.

The current rood or cross was put above the screen by Herbert Read of Exeter (well-known ecclesiastical restorers) in the early 20th century. What makes the Ashton screens special is that their paintings aren't confined to the nave side. Here 32 panels, in groups of four, include 'local' saints like St Sidwell and Bishop Boniface. Some saints still have disfigured faces from the time of the Reformation.

Venture into the chancel and north aisle chapel and the paintings and tracery are in some cases even older. The Annunciation covers gates into the chapel; the Visitation of St Elizabeth is its parallel, facing the chancel. Even more exciting, most paintings here have Latin inscriptions: like the superb *omnes resurgent in novissima tuba* – 'all will rise up at the last trumpet'.

Much of this richness was probably due to the Chudleigh family, whose vault was once inside the north aisle (Lady) chapel, which explains why a huge wooden wall monument to Sir George on the north aisle wall refers to his 'lying below'. The Chudleighs lived at Place in Lower Barton from the 14th century until 1745, when they moved to Kenn.

ATHERINGTON

—— This village appears in a booklet *North Devon Alphabet of Parishes* as 'Z is for Zider'. No prizes for guessing that it was in

a famous fruit growing area with many orchards both for cider apples and Mazzard Green cherries – which paradoxically are black.

Atherington's name is believed to come from the ownership of land here by King Athelstan. It saw several 9th century battles; only recently an axehead of similar dating was dug up. Athelstan held court in this manor, later the seat of the Champernowne and Bassett families. Umberleigh House where the Bassetts lived can still be seen along the A377 road towards Barnstaple.

When Umberleigh (the larger village) was a mere hamlet, Atherington had greater importance. There's evident pride here; Atherington was Devon's Best Kept Village in 1998 and won its past winners group in the year 2000. It still has a shop-cum-tearoom which advertises Sunday lunches in season, a hall where the playgroup meets and a Baptist chapel, in addition to St Mary's church. Inside here is the most complete rood screen in Devon: even a rood loft.

St Mary's lychgate is large and very long – it needs to be. Underneath is a stone coffin table, certainly in use in 1800, where the parish coffin rested. Unlike those whose family could afford to pay for their own, those unfortunates who were to be buried 'on the parish' were unceremoniously upended on the coffin table. Inspection suggests that the original stone is still present; the table's support is almost certainly restored. The shrouded corpse was carried into St Mary's churchyard for subsequent burial and the coffin returned ready for its next occupant.

AXMINSTER

—— By their very position some places are destined to become towns; Axminster is a classic example. Near the ancient Roman Fosse Way, later a Saxon settlement with a minster, its location made it a natural choice as a market and coaching town in East Devon.

Axminster still holds weekly livestock sales, with other market stalls outside St Mary's Minster Church. Most people connect the town with carpets, and Thomas Whitty's 1755 factory, revived after a spell in the doldrums from the 1830s by Harry Dutfield in 1936 can be seen in Silver Street – in use as a Conservative club.

There were numerous different industries, largely fuelled by water from the river Axe. Wool generated other work until the 18th century, swiftly followed by flax, through ropemaking to brushes.

At the foot of Castle Hill, used during fairs for trying out the soundness of horses, Coates Brush Works – later Bidwells – still stands, next to Castle Mill. The buildings are easily recognisable by their form: the brush factory having five bays, and three storeys of stone with brick dressings. Castle Mill rises behind it in three red brick storeys under a flat roof with castellated parapet.

Before the First World War 300 people were employed in brushmaking: from toothbrushes to hairbrushes. Many of them lived nearby in the mill cottages of Vale Lane whose exteriors are little changed.

Today Castle Mill has a deserted air; it most recently supplied pet and animal feeds. The old Brush Factory – one of two in the 19th and 20th centuries – has gone light-headed; it is a feather factory run by Jaffé, who dye and bleach feathers before manufacturing various articles.

Any recalcitrant males (or scolding wives) employed here might have been punished at Ducking Stool Bridge opposite. Sited on the mill leat, now somewhat overgrown, its sign reminds us this was Axminster's chastisement spot. The last known sufferer was a wife beater called Butcher, according to local historians. I wonder if he used to hit her with one of Coates' hairbrushes?

AXMOUTH

See **Seaton and Axmouth**.

BAMPTON

The town sign for Bampton shows pack ponies and the church – this was a market town from early times. We are in sheep country, where Bampton Notts and Devon Longwools once jostled for space in the lanes and behind hurdles at the town's sheep fairs.

Behind the Seahorse Inn at the top of town on Briton Street the ponies which largely replaced sheep at Bampton's October St Lukes Fair, after the Exmoor Pony Fairs transferred here, were sold in an orchard. Nearby is one of Bampton's old tollhouses; the lane beside it is the formerly cobbled Packhorse Way, which led across Exmoor to Watchet on the north coast. This tollhouse collected dues from those arriving from Exmoor and also from Tiverton. Square, two-storeyed, dating from around 1820, it is now a private residence.

Tolls would have been very lucrative; Bampton was not merely a market town but also a centre of the serge industry. No wonder a second tollhouse exists – now the town's library, formerly its local board office and reading room – at the end of Newton Square where it joins Back Street. This tollhouse dates from 1798; the name of the Honourable N. Fellows, Lord of the Hundred, also appears on a plaque. Would-be sellers from the west passed and paid their dues here; a third tollhouse guarded the approach to Bampton across Halfpenny Bridge, so named to reflect the cost to foot passengers.

Well House, on Brook Street just below a bridge over the Batherm, where old 'duck paddle' streams flow in from either side of the road, hides a secret in its tiny front garden. Under a large circular wooden cover is an old well fed by a chalybeate (mineral-bearing) spring. The spring comes from an area near Morebath, where marshy ground formed in a basin between two ridges, near the Shuttern Brook, also created a chalybeate watering place and gave that small village the latter half of its name.

There were moves to sell Bampton spring water in the 19th century until locals said it resembled liquid rust (due to the iron content) and wouldn't touch it. Someone in the area must have got over-enthusiastic: an 1888 map shows a spa marked on the spot.

I wonder how much you'd have had to pay for a pannier-full of bottled water at one of those tollhouses.

 # BANTHAM

See **Thurlestone and Bantham**.

BARNSTAPLE

John Penrose was just one of Barnstaple's wealthy merchants who became town mayor over the centuries. This self-styled 'capital of North Devon' has been port, market town, pottery centre, cloth empire and defensive fortress. Nowadays people visit for retail therapy or to 'shop fuddle' – a local expression meaning to stroll about without necessarily buying anything – to admire Barnstaple's prizewinning floral displays or to visit its heritage centre, pannier market or museum.

In 1575 when Penrose was born, today's pedestrianised centre would scarcely have been needed. The narrow Litchdon Street where he endowed almshouses was Barnstaple's main route towards Exeter; a coaching stop (Exeter Inn) and Brannams famous pottery were later built there.

Land owned by John Penrose in Hartland parish was assigned in his will, dated 14th June 1624, with an exhortation to 'find

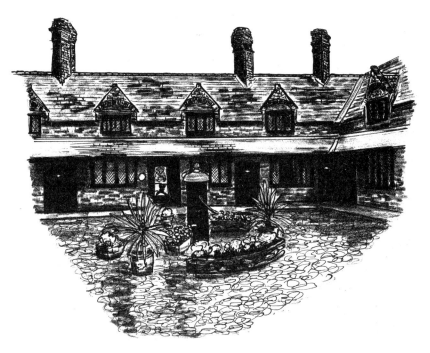

Penrose almshouses in Litchdon Street.

some place within the borough and parish of Barnstaple fit to erect an almshouse upon.' Penrose's twenty almshouses, each intended for two people, are still in use; if you check the notice beside their archway it may be possible to get a closer look. The colonnade of rough-hewn granite pillars fronting Litchdon Street reminds me of a more famous group at Moretonhampstead on Dartmoor. The Penrose Almshouses are gabled, with chapel and boardroom at each end, sensitively replaced windows and tall restored brick chimneys. Most of the houses surround an inner cobbled courtyard with old pump; behind are small gardens.

John Penrose could not have clasped hands over the Tome Stone in Queen Anne's Walk – the former merchant exchange along Barnstaple Quay – to seal bargains in front of witnesses. The present stone only dates from 1633; it contains the names of John Delbridge (mayor for a third term, merchant and prominent citizen), Nicholas Delbridge, Alderman and the previous year's mayor Richard Ferris on its sides. As the concept is Saxon maybe Penrose used an earlier version. This one got lost after use was discontinued in 1826, was rediscovered and mounted on its stone pedestal in around 1909.

Barnstaple's ancient charter fair is still celebrated, beginning on the third Wednesday in September. A procession of Devonshire civic heads is part of the fair's proclamation outside Guildhall and at three other points, following a ceremony inside (by invitation only) where ale brewed to a secret recipe is drunk and fairings including ginger snaps and sugared almonds are eaten.

BEER

This is the sort of place that looks as if it should have been a centre for smuggling – and it was. The little beach with its fishing boats, mostly used for crabbing, and high chalk cliffs for keeping a lookout for the Revenue Men have just the right feel about them. Jack Rattenbury – perhaps the best-known smuggler in these parts – was a native of Beer born in 1778 whose deeds are fabled; he wrote about many of them himself in 1837. A Rattenbury Day is held in late September, when pirates of all shapes and sizes cavort about the village.

It's strongly believed that Jack stored some of his illicit brandy, tea and tobacco in caves at Beer Quarry, about three-quarters of

a mile west of the village. A route said to lead to them from the sea has yet to be found, despite stories from elderly locals who claim they were taken there as children and shown waves breaking at the end of a passage.

With or without Jack's hoard Beer Quarry Caves are redolent with history. Old Quarry was worked from Roman times until the 19th century. Its stone is very famous and has provided parts of the Tower of London, Windsor Castle and one or two cathedrals including Exeter. Bovey House, a nearby Tudor residence of the Walrond and Rolle families, also shows off its fine qualities.

You can visit these caves for a reasonable charge and admire the huge underground cathedral, its Roman ante-chamber, a secret chapel used by Catholics in times of persecution and the main Norman quarrying area. Across a lane New Quarry was opened in 1883. Its stone was mainly used for church restoration work and, except for producing some lime, closed by the 1950s.

Drawn by the alcoholic connection? Sorry to disappoint, but the name Beer comes from Bera or Bere, and identifies with the Old English word meaning a grove or wood. Somewhere Jack (the lad) Rattenbury and his partners in crime would have found very useful to hide in on occasion.

BELLEVER

Clapper bridges on Dartmoor play second-fiddle to their acknowledged superior at Postbridge on the tinners' route from Chagford to Tavistock. At Bellever, also known as Bellaford and Bellavur in the past by those with far greater claims to Devon than I, there is another.

Bellever is a hamlet; it lies off the B3212 road south of Postbridge. Forestry Commission walks and a youth hostel attract backpackers and other Dartmoor walkers, but there is a car park for those who only want a short stroll. The Lych Way leads from a three-humped 19th century road bridge west and north-west onto the 'real' Moor.

This route was used for carrying coffins from Dartmoor Forest to Lydford for burial before the 13th century when Widecombe became the area's burial place instead – and may well explain why the clapper bridge came into being. Lydford's importance

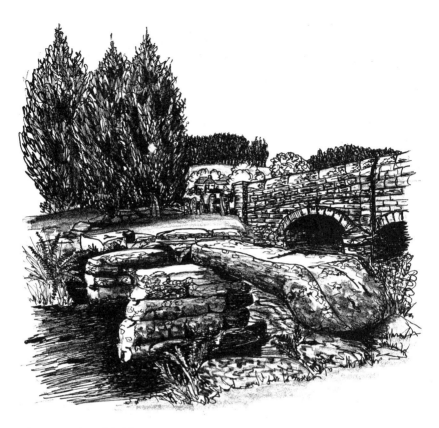

Clapper and road bridges.

for tin, its castle and prison, and its market ensured the route continued to be used.

The clapper bridge straddles the East Dart, like its relative at Postbridge within feet of a later road bridge. Unlike the Postbridge version it is minus its centre stone. This was missing in Dartmoor historian William Crossing's day: intentionally removed, as was once the similar stone at Postbridge. William Crossing claimed he discovered 'many years ago who did this', but evidently didn't see fit to have it replaced (or couldn't find the stone).

On a sunny day, with the gurgle of the East Dart coursing over stones in the riverbed it's a delightful spot to sit and think. I'd love to have seen the area on the Friday of Dartmoor Harrier Week (at Hocktide, just after Easter). It must have thronged with

carts and foot passengers heading for Bellever Tor. Here they once hunted and held a huge picnic, where everyone who was anyone made sure they were present.

🌿 BELSTONE

There aren't too many places even in Devon where cattle graze freely among houses nowadays. It's refreshing to enter the 'very Dartmoor' village of Belstone, past its common area, and see them – even though it's wise to watch where you put your feet!

To the left of Belstone's village green is its old manor drift pound, where some of these beasts might have ended up if their owners were not entitled to free grazing on Dartmoor. A 'drift', used to police this ancient right, was often organised without warning. A messenger on a swift horse blew his horn – by tradition through one of the holed stones found on Dartmoor – to announce it. Animals were driven to a gathering place, where walls or hedges allowed those not immediately identified by their owners to be impounded. Beasts unclaimed after three weeks would be sold, usually by the Duchy of Cornwall who owned much of the Moor. A charge for each 'stray' was paid before removal. The Duchy and the appropriate Dartmoor Commoners fixed the times for these drifts, and still do as they continue to take place for horses and ponies or cattle – although the number of drift pounds has dwindled.

At Belstone the walled area has been converted into a garden; 'to be enjoyed by all' says the plaque beside its entrance. Two large gate pillars were those between which the ducking stool once swung; a set of old stocks remains close by.

A walk around Belstone's largely granite and slate village doesn't take long, although it can be extended by following the beautiful Belstone Cleave, created by the course of the river Taw. St Mary the Virgin church is 13th century (unfortunately with 19th century restoration), there's a brook, somewhere to get tea and coffee and two gems not to be missed. The first is David Kidd's house where he restores and repairs clocks; you'd guess that was his profession, they're displayed in various windows. A short step across the road is Belstone's post office, with its old metal sign for a telegraph office. Nothing unusual about that? Take a closer look at the building; when Belstone moved from its

former post office (now a house) it took over an ecclesiastical building – a Zionist chapel to be precise.

❧ BICKLEIGH (NEAR TIVERTON)

Bickleigh shows visitors the face of Devon they want to see: heritage in an idyllic setting. It's easy, faced with its five-arched 'bridge over troubled water' which we'd all like to believe was inspiration for Paul Simon and Art Garfunkel's famous song, to forget the number of times the bubbling river Exe has flooded the picturesque thatched Fisherman's Cott – and many other properties here.

When I first saw a tourist sign to 'Devonshire's centre' in Tiverton several years ago it proved an irresistible draw. Where – and what – was it? Directions led to Bickleigh near Tiverton (to distinguish it from the other Bickleigh which lies close to Plymouth) where 'Devonshire's centre' is now Bickleigh Mill. By no stretch of the imagination is Bickleigh central in Devon – it's too far east. Perhaps the name was meant to convey that with restored mill wheel and workings on display, farm animals, trout ponds and maize maze (created afresh each year) – not to mention pottery, shops and restaurant – this IS Devon.

A trip over the bridges and down a nearby lane to Bickleigh Castle pays dividends. This 900 year old fortified residence of the Courtenay and Carew families is still a family home, open to the public several afternoons weekly depending on the season. Elizabeth Courtenay married and brought husband Thomas Carew to Bickleigh in the early 16th century. Previously the estate passed to younger sons among the Courtenays (Earls of Devon). Their courtship and elopement caused friction between the Courtenay and Carew families, until Thomas 'proved' himself by fighting at Flodden and being taken prisoner. On his release Sir Philip Courtenay made them a late wedding present of Bickleigh Castle.

Elizabeth is almost certainly buried in Bickleigh Castle's 11th century Norman chapel across the lane. It's amazing to learn that when the Boxall family bought Bickleigh Castle in 1907 they discovered this ancient gem in use as a cattle shed. The chapel is thatched and has a simple structure with a nave, a plain 12th century doorway with sanctuary ring and walls made from

rubble – with the exception of quoins, its plinth and window surrounds. Inside is an old lectern, an eight-sided font and an aumbry or cupboard where the chalice and paten for mass were once kept.

A local legend claims that the Carews were cursed by water – chiefly substantiated by the fact that Sir George Carew was Vice-Admiral in charge of Henry VIII's ship *Mary Rose* and went down with her in 1545.

🌿 BICTON

On the former A376 from Exmouth to Newton Poppleford, (now the B3178), Bicton was part of the East Devon estate of the Rolle family whose home, Bicton House, is now a college of agriculture in a classy rural setting, complete with lake. Next door its former gardens open as a tourist attraction throughout the year, with water features, greenhouses and orangery, church and extensive lawns and trees. The Rolle dynasty intermarried with another Devon aristocracy – the Clintons, whose relatives succeeded here in 1852 when John, Lord Rolle died without heirs. These names crop up all over Devon.

The family also owned nearby Otterton with its restored working corn mill. At the crossroads which link the main road with Otterton and Yettington, Lady Rolle had a structure erected which many people zip past without noticing. It pays to be aware of traffic when reading the four sides of her rectangular brick monument with granite cross on top, known as Brick Cross – for obvious reasons – or as the Scripture Stone.

Each face bears a tablet with destinations and an appropriate text. If you aim to travel to Otterton, Sidmouth or Culliton (Colyton), your text is 'O that our ways were made so direct that we might keep Thy Statutes'. This face usefully dates the cross as AD 1743. I won't spoil things by telling you the other messages.

Lady Rolle's scriptural approach may have been precautionary. Otterton's former cross was placed on this spot by Devon's Sheriff in 1580. He once had to order a witch be burned at its foot; until 1823 suicides and murderers were always buried in a pit nearby, following the tradition that they be interred at a crossroads.

In the late 20th century Brick Cross looked rather sad; the Otter Valley Association had it restored in 1985 to continue delighting

us with its moralistic directions. I'd recommend following the face which directs you into the village of Otterton, not only for its mill and Duckery café but also for particularly good examples of Devon thatch along the main street, where many cottages are reached by crossing a small stream. It leads in turn by an up and downhill route to Ladram Bay, whose caravan site only slightly detracts from stunning red sandstone stacks off the small beach.

BIDEFORD

Bieda's or Bede's family probably settled at the ancient ford here across the river Torridge: the 'abiding place' – hence Bideford. It was replaced first by a wooden bridge and in 1280 by the much-repaired and widened 24-arch stone version seen today. The old wood still remains inside some of the masonry which may explain why the arches look uneven.

Bideford's place in history as a North Devon port and market town (both pannier and livestock markets still take place regularly) has been enhanced by one special literary connection. It is Charles Kingsley's 'little white town' where he wrote much of the nine hundred and fifty words of his original manuscript of *Westward Ho!* in 1854.

Kingsley's statue, sculpted in 1906 by Joseph Whitehead, occupies pride of place on the Quay beside Victoria Park. In Northdown Hall which stood back from The Strand, Charles Kingsley completed his masterpiece. To discover where this tale of Amyas Leigh began, cross the Torridge by the old bridge to East-the-Water, described by many as the town's Cinderella. Immediately in front is the Royal Hotel; its Victorian façade hides several secrets.

Kingsley stayed in the former home of merchant 'prince' John Davie – embodied in the hotel's north end – when he arrived in Bideford. It's generally accepted that the first chapters of *Westward Ho!* were penned here, and he was believed to have written further chapters at Jessamine Cottage in nearby Clovelly. The character Salvation Yeo is understood to be based on a namesake there. Kingsley was born further south, at Holne near Buckfastleigh, where his father was temporarily rector.

If you ask nicely the delights of the Kingsley Rooms – there are two – will probably be revealed. Climbing the late 17th century

oak staircase as Kingsley did prepares the eye little for the wonderful plaster ceilings, attributed variously to Devonian John Abbott and to Italian influence c1689. They are garlanded with flowers, fruit, strange masks and foliage – not forgetting the occasional serpent hanging menacingly downwards.

A picture once described as being of Elizabethan seafarer Sir Richard Grenville is thought, partly on the basis of a *Punch* magazine 1889 advertorial on the Royal Hotel, to have yet another Kingsley connection. If it is John Strange, painted by Van Dyck, he was grandfather to Rose Salterne, the fickle Rose of Torridge – in *Westward Ho!*

 ## BIGBURY (WITH BURGH ISLAND)

Pottering here through the narrow roads of Devon's South Hams is a voyage of discovery. Agatha Christie must have enjoyed it; she used Burgh Island as a hideaway, staying at its art deco hotel to write *Evil Under the Sun* and the book (and play) whose title was later changed in the interests of political correctness from *Ten Little Niggers*.

To reach Burgh Island a sea tractor of science-fiction design ploughs across the sands from Bigbury-on-Sea, where pilchard-curing cellars – an industry from which Pilchard Inn on the island got its name – have now been replaced by up-market housing and tourist amenities.

Many visitors drive steadfastly through the village of Bigbury itself, located $1^1/_2$ miles inland – which is a pity. On the approach from St Ann's Chapel (another small village with a slice or two of history) is Bigbury Court farmhouse, former home of the de Bykebury family, who lived in the area from King John's reign. Beside the main entrance is a curious circular structure, its roof somewhat grassed over. This was the de Bykeburys' dovecot, from days when such birds weren't reared entirely for ornament.

Birds are in evidence in Bigbury; in St Lawrence's church is a strange lectern whose bird has undergone a head transplant. Made by Thomas Prideaux as a gift to Exeter Cathedral's chantry chapel, this well-travelled owl was given to Ashburton's St Andrew's church by Bishop Oldham in the early 16th century. It 'flew' south to Bigbury 300 years later: for a transfer fee of 11 guineas. An incumbent at St Lawrence's found its beady eyes

unnerving and decided to remodel the carved lectern as an eagle.

The unknown sculptor has found it difficult to marry the body feathers of an owl to the head plumage of an eagle. The head's direction significantly turns away from the church pulpit! Another large bird sits on St Lawrence's tower: a traditional weathercock.

Villagers in this compact area of thatch and slate-roofed cottages, garage and Royal Oak Inn are evidently used to assorted ornithology. They have the only church I've ever visited where a bead curtain covers the entrance doorway. 'It's to keep the birds out,' explained a parishioner. I felt like telling him he was shutting the stable door after the horse had bolted – but it's best not to mix your metaphors.

BISHOP'S TAWTON

This village, popular with anglers on the river Taw and split by the A377 road south of Barnstaple, has an ancient claim to fame. During medieval times the area was a valuable property owned by the Bishops of Exeter, who had a palace here, now part of Court Farmhouse next to St John the Baptist's church, with its unusual octagonal stone spire.

Prior to the bishopric transferring to Exeter in AD 1050, Crediton had the see. Was Bishop's Tawton perhaps a palace even then? In all events it was in use for Exeter's bishops, who controlled Devon ecclesiastically, until 1440 and remained church property until the Reformation.

The current building represents an obvious mixture of periods, but above one ground floor window is a very old lintel; some stonework is evidently ancient, especially in a side wing. Three corner towers and battlements date only from c1800.

Between Court Farmhouse and a village hall, built as the National School in 1841, an old building set at right-angles to the house has been named 'Tithe Barn'. Its location and the old walls make this a credible choice.

The main village clusters along the old road to Barnstaple, known as Village Street. The Three Pigeons Inn dates from 1623, in a 15th century building said to be haunted by a restless monk. A 14th century longhouse here was also once an inn and meeting house – all very ecclesiastical.

BOVEY TRACEY

Bovey Tracey is in clay country; its river basin has produced excellent raw materials for years and made the fortunes of numerous local families. Today its industrial estates bustle with businesses of all kinds. Clay is well represented by tile manufacturers and also by an internationally famous teapot company, producing character pots of all shapes and sizes, adjacent to a House of Marbles. The latter two both have well-advertised tourist attractions attached to them.

In the town itself, gateway to the Haytor area of Dartmoor, history and tourism sit easily together, even if the traffic does snarl up at times. Bovey Tracey was a wool town with markets and fairs by the 13th century; it had a Norman monastery whose sheep runs doubtless added to the town's prosperity.

Little remains of the monastery apart from Cromwell's Arch – well hidden at the bottom of Hind Street and Abbey Road, behind the Cromwell Arms Hotel. The monastery was built c1170, firstly for a French order, then in the 13th century taken over by the Hospital of St John of Bridgewater. It survived like most only until Henry VIII's purge, closing in 1535.

Cromwell's Arch.

There are actually two arches; the larger, once in the monastery's south wall, sits in splendid isolation at the foot of Hind Street. A smaller arch is now the entrance to a Baptist graveyard. Local Baptists were allowed to build their chapel on the site c1824.

Why Cromwell's Arch? The most likely reason for its name comes from a major battle fought at nearby Bovey Heath in 1646, when victory went to Cromwell's Parliamentarians. I can't help wondering about the nearby hostelry's name, however. It could be that the Cromwell Arms came first and Cromwell's Arch – restored in parts but clearly showing some old pillars and stonework – took its name purely from a geographical location.

Names were evidently prone to change in Bovey Tracey. The church, now dedicated to SS Peter, Paul and Thomas of Canterbury is believed to have acquired the last saint as a deed of penance by one of his four murderers in Canterbury Cathedral. Why was de Tracey involved? Some historians suggest he thought Thomas was making free with his wife while he was away; she was only consulting him in religious matters. Others dispute this version of events; interestingly the church living remains in the gift of the Crown.

BRADNINCH

The Mayor of Bradninch is once supposed to have taken precedence over that of Exeter. When Exeter's Mayor wanted to arrange an important meeting, his Bradninch counterpart insisted he call upon him and was discovered on a roof, following his other occupation as a thatcher; the Exeter dignatory was expected to climb up and join him.

True or not, Bradninch had early borough status and has important connections with the Duchy of Cornwall; hence the Prince of Wales feathers alongside arms of a black eagle on its town hall. Most Princes of Wales have also been Dukes of Cornwall. Their device of three white ostrich feathers is ascribed to Edward the Black Prince (1330–76) who allegedly acquired them from John, King of Bohemia when he fell at the battle of Crecy. The black eagle came from Emperor Charlemagne via Richard, second son of King John who gave Bradninch its charter. He was also styled 'King of the Romans'. No wonder the mayor was self-important.

Bradninch is a former woollen town, not very exciting architecturally, saved from possible extinction in the 18th century by conversion of a grist mill in the nearby river valley to papermaking by Edward Collins of Topsham. By 1767 there were others nearby, all family businesses. A lease was taken in 1770 on Devon Valley Mill by William Matthews of Huxham and Thomas Dewdney of Newton St Cyres – who continued alone in 1783, handing on to son John.

The mill burned down in 1821 in a wind so strong it carried burning paper up to five miles away and was rebuilt with a water turbine for steam power. The ready supply of water from the nearby Culm made this an ideal spot to carry out papermaking; Bradninch developed and benefited accordingly.

Owner John Dewdney was nationally renowned in the 1850s. He was the first John Dewdney's nephew, and produced the earliest glazed English writing paper here, supplying paper for the catalogues publicising the 1851 Great Exhibition. By now the 17th and 18th century process of treating rags with hot water and chemicals had been superseded by timber pulp.

The mills at Bradninch passed to the Collins and Hepburn families before becoming part of Wiggins-Teape in the 1920s. Today largely 20th century buildings close to a railway level crossing at Hele are part of Mead UK Ltd, with an Ohio parent company. It's sobering to realise that, of 15 mills along the river Culm in the 19th century only Bradninch's paper mill and one at Cullompton remain.

BRADWORTHY

—— Called Bradry by locals, Bradworthy was an early Saxon settlement – probably before AD 720 – and has one of the largest village squares in the West Country. This is where Bradry Fair was always held; it received its first fairs charter in 1200 for St John the Baptist's feast day. A later fair, held in early September, was revived in the 1990s. 'After Bradry Fair comes winter air', it was said.

I expect good use was made on fair days of the pump erected at one end of Bradworthy's Square to commemorate Queen Victoria's Diamond Jubilee. One of the reasons for the village's development in Saxon times was the presence of a spring of

exceptionally good water, and it was this which a water diviner was called in to locate, at a cost of ten shillings, before the 40 foot well was sunk under a pump house. Public subscription paid for the work and its square stone building above – all by kind permission of the Lord of the Manor. There is still a lead-lined trough, pump handle and spout visible through the grille that is necessary today to prevent misuse or vandalism.

The Square is very much the hub of Bradworthy village. Old Inn stands guard over the churchyard entrance – a former coaching place on the old road to Bude in North Cornwall, part of it is thatched and looks to pre-date coaching days. Post office, general stores, butcher's and hardware shops and even a sizeable furniture and carpet shop and a veterinary practice ring the central parking area. The presence of a small industrial estate on its fringe no doubt provides custom for a fried fish shop and tearoom. A new memorial hall is set back from the Square itself, creating an impression of a lively community ringed by narrow lanes and farmland.

The gnome-minded are catered for at nearby West Putsford, where an entire colony dwells in pampered luxury and where the wearing of a pointed hat is positively encouraged. A strange community to hide in the Devon countryside, especially in the 21st century.

🌿 BRANSCOMBE

—— Thatch, thatch and more thatch! In this East Devon combe where three valleys join and streams descend to Branscombe Mouth, cob and thatch buildings are two a penny.

'Please drive carefully – cats crossing', says a highly-coloured sign at the top of Branscombe's classic long village street. At the car park entrance alongside the village hall St Branoc's well collects your 'honesty' fee; close by are three National Trust properties, of which Branscombe Forge is perhaps the most unusual.

Here is the only working thatched forge in the country, run as such successively for at least 200 years. Andrew and Lynn Hall, qualified blacksmith and farrier respectively, are the current craftspeople. Lynn's skills are mostly taken to customers in a mobile unit today; Andrew, who also trained as a precision

engineer, handcrafts anything from knives to garden tables under the low-slung forge roof.

There are records of a Norman forge in Branscombe, whose work also included wheelmaking. An old binding plate for clamping wooden wheels remains on show and if some of the heat is engendered by modern means, the old forge still gives off that image of light and molten metal of times past.

The National Trust took over part of Weston Estate in 1965, transferred by the Inland Revenue who doubtless acquired it as death duties. The Trust's Branscombe assets included the nearby thatched bakery, now a tearoom, where until 1987 the Collier brothers baked in ovens fuelled by wood faggots. If you want to see where some of their flour came from, it's only a short step across the footpath to Manor Mill: one of two grain mills once supported by village life in this picture postcard valley.

🌿 BRAUNTON

—— All the way to North Devon to see a field? There may still be plenty of fields all over Devon, but none like the Great Field of Braunton.

This is the village of St Brannock or Brynach, a 6th century missionary who by legend floated from Wales on a rock – his own tombstone. Celtic priests usually carried one with them, just in case. He was apparently a farmer-priest who used his affinity with animals to help convert the locals. The best legend about St Brannock concerns the location for his church. In a vision God told him to build where he found a sow with six piglets, which proved to be today's Braunton, claimed to be the largest village in England (where have I heard that before?). A boss in St Brannock's roof is cited as the legend's proof, but a sow and piglets is a not uncommon ecclesiastical device for mother church and congregation.

The Great Field's history is more certain; an excellent display in Braunton Museum in the newly-converted Bakehouse Centre brings to life the history of one of only two places in England where field strip cultivation is still practised on a significant scale. Now worked by four or five men in 84 strips with 24 separate owners, it covers some 320 acres, still surrounded by a Great Hedge.

By 1227 when Braunton had two manors: Braunton Gorges and Braunton Abbots, the field was well established on the three strip system growing winter and spring corn. It probably survived periods of mass enclosure due to having many owners in several manors, and remained largely intact.

The furlongs have names like Bowstring and Cutterborough; you can reach them via the aptly named First Field Lane or Greenaway, beyond Braunton's cricket ground.

Braunton itself is busy at all times of year, more so in summer when the nearby Burrows, Saunton Sands and the sweep of Croyde Bay draw walkers and surfers to the area, and there are plenty of shops and cafés. It is a village where small boatbuilders and sail lofts once flourished. Until the 19th century people worked the land – or the sea. Along East Street and up through Church Street is the old part of Braunton where terraces of thatch, cob walls, St Brannock's church and the old church house are located.

BRENTOR

Climbing the 'burnt tor' off the road from Lydford to Tavistock is not advised on a windy day. Unlike the nearby village of North Brentor, built in the lee of this former volcano – or at least its remnants – the church of St Michael de la Rupe stands about 1,100 feet (335 metres) above West Devon. Its site marks an Iron Age earthwork.

Robert Giffard is credited with building here first in around 1130; he was Lord of the Manor of Lamerton. In case you can't face the climb to the 40 ft by 14 ft church whose tower dates from the 14th century, St Michael of the Rock comprises nave and chancel in volcanic stone quarried from the tor itself. Battlements were added to the tower about a century later.

Brentor is one of many areas where Devonians believe the Devil took a hand in affairs. It was intended, says local legend, to build at the hill's foot, but one morning all the stones had been shifted to its summit. Several men kept watch when this was repeated and a dark figure was spotted at midnight kicking down walls before removing the stones uphill. Eventually people decided to give Satan his way; his power couldn't stop them having a church, but he had made it relatively inaccessible.

A further twist (there is never only one version of a Devon tale) gives archangel St Michael a role. He threw the Devil back to Brentor's foot from the summit in retribution.

Alas for such stories; prosaic historians describe St Michael de la Rupe as a 'votive' church. Bestowed by a merchant at sea approaching Plymouth after narrowly escaping shipwreck, who vowed to build a church on the highest peak he could see (possibly the aforementioned Robert Giffard), it was built by monks from Tavistock Abbey.

Should you wonder how North Brentor parishioners fare on winter Sundays, let me reassure readers. A chapel of ease in the village itself was consecrated Christ Church in 1857. The majority of services and all burials have been held here ever since. Soil on Brentor's summit is as they say 'rather thin' for the latter – but the view's amazing.

BRIXHAM

────── Anyone who knows Devon will be familiar with Brixham's famous harbour, its fish quay and distinctive boats with 'BM' painted on their sides.

Many visitors make pilgrimage to All Saints' church where the Rev H. Francis Lyte was the incumbent for Lower Brixham; he's the man who wrote *Abide With Me* – some say on the afternoon he preached his final sermon – not long before his death in Nice in 1837.

Henry Francis Lyte lived at Berry Head House from 1834, a former Napoleonic military hospital on the headland which towers above Brixham. The Borough of Torbay purchased Berry Head from trustees of the Lyte family in 1969 and it has become a famous nature reserve, preserved for everyone's benefit.

Dotted about the headland are relics of the area's less peaceful past, as well as one of the shortest lighthouses in the South West. Built in 1905 at the end of a 200 foot limestone cliff, neither it nor the coastguard station built over an old powder magazine need to be tall to perform their job.

Brixham had an early promontory fortress here in Roman times whose ramparts lasted until the French threatened invasion in 1793. Within ten years wooden huts placed here to house the troops who manned guns mounted on the Head were

Looking south from Berry Head.

replaced by two forts: North and South, known as One and Three. 'Two' was never completed. The dry moats and drawbridge accessed stone ramparts, huts, officers' mess, kitchens and magazines, welcomed by troops whose life in their wooden predecessors resembled a penal settlement. One, George Chubb of Lt Col Bastard's company, was confined in a 'black hole' for 48 hours and drilled for getting drunk too many times in Totnes. Can you blame him?

Wandering among a miscellany of wild flowers and the earthworks and walls – even two 18 pounder cannons similar to those on the redoubt, retrieved from a new life as bollards on Torquay harbour – is an interesting experience. Fulmars and kittiwakes, guillemots and gulls nest in the cliffs; you can get refreshments in a former guardhouse, join the South West Coast Path – or puzzle over space-age buildings north-west of the car park. These form a Very High Frequency Omni-directional Range (VOR) station with navigational aids, including a beacon,

for civil aviation. What would the Rev Francis Lyte have made of such things?

BROADHEMBURY

When lawyer Edward Drewe built his house Grange at a former Dunkeswell Abbey farm in 1603, he laid foundations for the pretty cob and thatch Broadhembury – an archetypal estate village. His H-plan house, completed by son Thomas, was the third Drewe property in the county.

There are numerous Drewe memorials in St Andrew's church, including the funeral helmet of Francis Drewe which is above his monument in its Lady Chapel. The Drewe Arms, part-thatched nowadays, was Broadhembury's church house, with another property, Churchgate, pre-dating the Drewe influence as a probable medieval priest's house.

There was a church house in most Devon parishes; its earliest function was as a venue where parish ale was communally brewed, and it was used also for feasts – where the ale was often consumed. Profits went to church funds. Secondary use as temporary dwelling for priests or for workmen extending and embellishing the church was common. Some of the county's numerous Church House Inns began their lives in this role; most were conversions, possibly after an edict of 1603 forbidding all the social events for which church houses flourished. Becoming an inn allowed the parish 'parties' to continue.

Broadhembury, whose name comes from Hembury Fort in the Blackdown Hills, thought to be the best earthwork in Devon, was owned by Brictric before 1066, given to Odo, half-brother of William the Conqueror, and thence into ownership by Dunkeswell Abbey (see Hemyock) before becoming the estate village for the Drewe family. They owned nearby Grange until the 1890s.

Today Broadhembury attracts visitors chiefly to enjoy its picturesque ford and neighbouring bridge at the bottom of its main street, numerous beautifully maintained thatched houses and cottages and St Andrew's whose 100 foot high tower has a spire in one corner. It is built in a mixture of flint, Beer stone, volcanic stone from Thorverton and sandstone. People also make a beeline for the award-winning Drewe Arms and the post office-cum-village stores and information point.

BUCKFASTLEIGH

The name means pasture or glade of the stronghold of the buck; you won't see too many male deer loose in the area nowadays.

There is a lively air to Buckfastleigh during the tourist season, when several attractions draw in visitors. There's even a bus at peak times to ferry holidaymakers between Buckfast Abbey, a butterfly and otter attraction, South Devon Steam Railway, a major farm and wildlife centre and Buckfastleigh itself.

Tucked into Fore Street is a pub where 'time was never called'. The Valiant Soldier, once a haunt of working men associated with sheep and wool, was probably originally two buildings. Giles Dolbeare's name appears in 1783 as landlord; no name is given for the inn until 1813 when the Valiant Soldier was purchased for £400 including gardens, stables and brewhouse.

Who was this valiant soldier? One, it is believed, from the Napoleonic Wars. A William Foster ran the inn for almost 50 years while combining his duties with being postmaster and thatcher. In the pub's 'attic collection' a lantern from outside the pub pinpoints a later landlord as James Salter.

When the Valiant Soldier passed to Exeter brewers Norman & Pring it had at least three more landlords before Mark Roberts arrived – destined to be the last 'mine host'. Brewery changes, Mark's ill health and declining trade all took their toll. When the doors closed in the 1960s everything in the bars was left precisely where it had been when in use. Mrs Roberts purchased the building as her home – with a covenant preventing reopening as a public house – and stayed there for another 30 years. She was, fortunately, a natural hoarder.

The Valiant Soldier is not only unique hidden Devon exposed to view; it represents a triumph for a community in achieving its twin goals of opening the time-capsule as an attraction and putting together a community museum. With the help of numerous bodies and European assistance, a dream was turned into reality.

Nothing has been imported; it was all there awaiting discovery. Use of sound effects and audio memories from people in Buckfastleigh recreate wartime privations, days when Hamlyns Mills still brought the town prosperity and the pub's final fling.

Why is the name BUCKFASTLEIGH unusual? It contains half of the 26 letters of our alphabet – and none is repeated.

BUCKLAND IN THE MOOR

—— The first time I visited Buckland in the Moor rain came down in stair-rods and a friend who wanted to photograph the nearby Ten Commandments Stones discovered at the top of Buckland Tor that there was no film in her camera.

Buckland in the Moor attracts shoals of visitors who take pictures of its groups of thatched cottages, visit the craft centre and often rush off to the next Dartmoor guidebook 'must'. Stay a little longer and seek out St Peter's church, if only to wonder why the numbers on its clock's dial have been replaced by letters. By reading clockwise (no pun intended) from nine to two, then anti-clockwise from eight to three o'clock positions you'll get the answer: MY DEAR MOTHER. Whose? One William Whitley of nearby Buckland Court, Welstor. Whitley family tombs are in St Peter's graveyard. He erected the clock in 1930, and gave three bells for the tower. If you're lucky they will play *All things bright and beautiful* on the hour.

The local story is – before you engage the 'aa…ah' factor – that this clock was a conscience present. His mother was sadly neglected towards the end of her life.

It is the same William Whitley whom we have to thank for enhancing a wonderful view over the Dart valley, across Holne Moor and even to the English Channel on a really clear day, at nearby Buckland Beacon. Its grid reference is 735731; cars can be driven as far as Buckland Common past Ausewell Cross and parked on the roadside opposite a gentle slope and track leading to the beacon.

The two Ten Commandments tablets, now rather worn but still readable, commemorate arguments over introducing a new Book of Common Prayer in 1925 favouring Anglo-Catholicism. The House of Commons rejected it twice; when the Lords agreed, it was only brought in by the House of Convocation as a temporary measure. William Whitley was so delighted at the House of Commons' sense, he employed W. Arthur Clement, claimed by both Exeter and Exmouth as one of their sons, to engrave the Ten Commandments on his nearest highpoint. Clement lived there in a hut whilst doing so throughout the summer of 1928. If you go to see them, check your camera *before* setting out.

BUCKLAND MONACHORUM

Over Roborough Down from Yelverton sheep and ponies wander at will, before the road drops towards Buckland Abbey and Buckland Monachorum. Hardly surprising that this is a 'Drake' village, being only a short distance from Buckland Abbey which Sir Francis purchased in 1581. He often visited brother Thomas, after whose family branch a chapel in St Andrew's church bears the famous name. The original carved Drake pew and frontal sits somewhat carelessly covered in service sheets at the rear of the north aisle. Close links between the church and Buckland Abbey's monks culminated in the last abbot, John Toker, becoming vicar at St Andrew's in 1557.

Doorway to Lady Modyford's school.

Buckland has its Drake Manor Inn – or rather two; the earlier was a church house until 1702 when benefactor Lady Elizabeth Modyford endowed another. It followed the tradition of such Devon properties in becoming a hostelry.

Lady Modyford, widow of Sir James (Baronet), was responsible for another building of importance in Buckland Monachorum: its school. In 1702 she endowed it as one of a series of properties which form an interesting corner outside the churchyard gate. A sum of £7 10s 0d yearly was allowed for a schoolmaster – whose house later adjoined – to teach reading, writing, the casting of accounts and catechism in the Anglican faith. Six children whose parents were unable to pay benefited; in addition Bibles, prayer books and outer garments of blue cloth were provided.

The schoolroom was originally a single ground floor structure with a Tudor style porch, granite doorways and arched windows. Why does the plaque above its doorway credit another local worthy? When Lady Modyford's establishment fell into disrepair extensive landowner Manasseh Masseh Lopes of Maristow took over its upkeep. It was not properly restored until 1830, when Sir Ralph Lopes completed the work in memory of his ancestor.

Lady Modyford evidently held education to be of importance; she founded another such school at nearby Walkhampton a year earlier which provided education by 1785 for 30 boys and 10 girls. This was rebuilt in the mid 19th century. Lady Modyford's Buckland school is no longer used for its intended purpose; modern Church of England aided buildings named for St Andrew stand beyond an ex-Baptist chapel in use as a Christian holiday and conference centre.

BUDLEIGH SALTERTON

Butt of music hall jokes, inspiration for Sir Walter Raleigh's voyagings or – as neighbouring Exmothians once called it due to its popularity with returning colonials – the Curry?

Budleigh Salterton's High and Fore Streets, filled with shops where service still means something, lead to its two best-known features: Fairlynch Museum & Arts Centre and the long shingle beach towards Otter Mouth with an excellent riverside walk beside its nature reserve. Just below Fairlynch, housed in a picture postcard thatched property built for ship owner Matthew

Lee Yeates and noted for its delectable collection of costume, is The Octagon. Within its distinctive walls John Everett Millais painted *The Boyhood of Raleigh*. Opposite is the very wall, restored in parts, which featured in this famous picture.

Raleigh himself lived at Hayes Barton near East Budleigh, a few miles inland. Young Walter knew the Otter valley very well, enjoying the relative freedom of a country squire's son; it's not unreasonable to imagine him drinking in tales of an old salt beside the water at Budleigh Salterton, deciding that this was the life for him.

This small town, which offers spectacular sunsets due to its location, has a very staid and settled feeling. Budleigh Salterton has become a great place for benches. They stand in an ever-tightening line from Otter Mouth to West Cliff, above The Rosemullion. Each time we visit there are more, paid for by donations in wills, or by sorrowing relatives who want to remember their loved-one with a seat in a favourite spot (if it's not already occupied). At my last count there were 94.

It makes strolling the promenade easier for those who continue to 'sunset' here, takes away that feeling of frustration when there's nowhere to sit on a balmy evening, saves the councillors money – and makes for enjoyable reading unless they're all occupied. 'Enjoy the spirit of peace in this place in loving memory of…', says one. Some offer a philosophy: 'Stay a long time as did she, enjoying Budleigh Salterton by the sea'. My favourite? One overlooking the river Otter's mouth in memory of Dr Nelms: 'who spent many happy hours sailing his little boat in this pleasant bay.' Who could ask for more?

CHAGFORD

Chagford is vintage Dartmoor, with ancient origins as a stannary town; some historians give 1305 and others 1328 as the official date when tin was first brought here from the mines for assaying and grading. The Moor is all around and St Michael's churchyard is a good place to look over the thatch and slate roofs and enjoy its views.

The old 'pepperpot' market house in The Square dating from 1862 is still one of its most photographed buildings – even if everyone's picture is invariably spoiled by hatchbacks and

four-wheel drives. I was amused by a press report of 1984 that it had been 'given a new lid', without louvres, to keep out pigeons. The history of Chagford's Whiddon family, whose town house was what is now the Three Crowns Inn, includes a sad tale in their long association with the place, and one that lovers of R.D. Blackmore will recognise. In the 1640s daughter Mary was shot by a jealous lover as she left St Michael's church after her wedding. There's a commemorative plaque on the south wall.

Where High Street joins The Square, two fascinating family businesses offer just about anything for enjoying Dartmoor, renovating house and garden or keeping the family amused. Inside one – James Bowden & Son, founded 1862 and still going strong – lurks Chagford's secret. You'll need to persist and not be diverted from your goal to find it behind the gardening section in this rabbit warren; it's worth the hunt. If the main shop's old-fashioned, what about its shop museum? In the 1980s, using a reconstructed frontage of J. Bowden – Smith & Ironmonger, the family put together anything and everything from their old stock and their old properties. Bluebags struggle for space with Monkey Brand soap and cardboard milk bottle tops. I spotted a baby's gas mask of the sort my parents couldn't put me in for fear I'd have convulsions and … no, better not spoil it for others. It was created in memory of Aunt Aggie and Uncle Tom Bowden and Winnie and Jack Smith. Nearby are photographs of old Chagfordians like James Perrott, who started the Dartmoor Letterboxing craze. Unlike most other letterboxes, whose stamps are under boulders, across bogs and suchlike on the Moor, here you simply admire and stamp your book.

CHITTLEHAMPTON

—— With a name like Chittlehampton it's hardly likely the patron saint here would be a commonplace John or Mary. St Urith or Hieritha is patron saint in this centre of Saxon colonisation, she's of Celtic origins and has a well and a hymn in her honour.

Chittlehampton – 'farms of the dwellers in the cietel (hollow)' – is an attractive village, especially around its Square where church and well are both situated. The post office and stores are called 'Chittle Chatter'. Below the Square is the Bell Inn, built in

1888 by Rolle Estates, who pop up all over Devon. Is this the actual site of St Urith's Well? Nobody seems quite certain.

The pump at the lower end of Chittlehampton's Square is the focal point for the annual procession through the churchyard beneath 12 beech trees which meet overhead, for the well blessing and hymn singing each 8th July. Posies of flowers are laid on St Urith's tomb; she is buried within the small chapel north of the sanctuary, where there was an image of the saint – or under the church tower, depending on who you believe.

Urith's story is told in the hymn on the last page of a commonplace book belonging to a 15th century monk at Glastonbury Abbey, found by Dr James, a Cambridge antiquary. Rev George Woodward, the vicar of St Urith's in 1936, made a free translation in five verses which tell the story of her martyrdom. Like St Sidwella in Exeter, it's an 'innocent Christian maiden with pagan stepmother and heathen fellow workers' scenario. Urith was attacked in the harvest field and butchered by scythes, apparently at her stepmother's instigation – as was St Sidwella. 'Where the holy maiden fell, Water gushed forth from a well, And the dry earth blossomèd,' says part of the hymn's fourth verse.

When the well was replaced with a pump is a moot point. Today it comprises a single pillar with handle, a large tap aperture and a huge ball set on the top. Hieritha and Urith were perpetuated as girls' names in Devon well after the 16th century. Urith has been a traditional name in several generations of the Trefusis family who became by marriage united with the Rolles and Clintons.

CHUDLEIGH

At Chudleigh a vast episcopal manor for the Bishops of Exeter was designated in 1081, lasting until 1550. It was particularly favoured by Bishop Edmund Lacy (sometimes Lacey), incumbent between 1420 and 1455, as his main rural palace – hence the name given to one of Chudleigh's remaining public houses, once known as the Plymouth Inn and said to have been part of a monastery.

A clue to Chudleigh's 'hidden' choice lies in the alternative name for an area near the town's war memorial: Conduit Square. Beside the memorial is an obelisk, erected by Harriet, Dowager

Countess of Morley in 1879, which once had a tap on it; what flowed out was part of one of Bishop Lacy's best ideas: potable – as in fit to drink – water.

It is traditional that the Bishop devised the system whereby water from a spring on the lower slopes of Great Haldon was controlled by a small weir, to be carried through channels, leats and drainage pipes over three miles, following natural contours. It was installed c1430, primarily for Edmund Lacy's own use at the palace; because it had to run north-south through the town he allowed townspeople a limited supply.

Climb New Exeter Street and beside a postbox in the wall on your right is the first wall niche or, as a plaque says, 'dipping-place of pot water: ancient town supply provided by Bishop Lacey'. A second niche with a slate shelf inside near the top of the street bears a similar plaque; they were positioned throughout the town. Chudleigh evidently kept the water running once the bishops had abandoned the palace, whose remains south-east of the main street are few. In 1640 four yeomen of Chudleigh appointed mason James Moore to keep the courses open for a 21-year term, on receipt of an agreed set fee.

Alas, development of a new bypass in 1973 cut off the water supply. If you need refreshment now, several inns and the odd teashop dotted among the usual town shops, a traditional bakery and butcher's will have to suffice.

CHULMLEIGH

—— Not many Devon villages, even one which was once a town, can boast an 18 hole short golf course in their heart, with 18 different greens, clubhouse and 'pro' shop. It rates par three if you fancy a game.

Chulmleigh's setting in the county's heartland gives a clue to its former wealth. So does the *North Devon Alphabet of Parishes* plaque ('North' Devon seems elastic, geographically). 'W is for Wool' it reads, located on the 1894 market house which later became a basket factory. Wool and the sheep which produced it were Chulmleigh's raison d'être from the 14th century until the late 1700s. Another reason why Chulmleigh once flourished was its location prior to 1830 on the main road from Exeter to Barnstaple.

Old Court House Inn along the South Molton road was formerly called the Barnstaple Inn after this route. It dates from 1633, and is built of stone and thatched; upstairs is a four-poster bedroom with a coat of arms from its days as a courthouse. The main street still manages to support a range of shops, a bank and a café. Inns were prolific; they included around 14 hostelries the Kings Arms, now a house of the same name, and a Black Horse Inn, renamed the White Hart after it acquired a dodgy reputation when navvies drank there while building the Exeter to Barnstaple railway.

As it was a market town, whose old sheep fair is still a major attraction, Chulmleigh's inns doubtless made a reasonable living. Chulmleigh Old Fair's charter was granted by Henry III c1253, to be held on the Feast day of St Mary Magdalene and a day either side, although records suggest two fairs were taking place as early as 1242.

Chulmleigh's white gauntlet 'fairs glove' is claimed to originate from Henry himself as a signal to his followers, some of whom visited fairs overturning stalls, stealing livestock and terrifying the populace, that the fair was under his protection. An interesting story; it's likely that the glove was a sign to a largely illiterate people that the rules of fair prevailed.

Except during the 2001 foot and mouth restrictions, Chulmleigh's fair has continued its ancient sheep show and country market, together with all the ceremonies of proclamation and glove – and is one of those in Devon to include a money scramble.

CLOVELLY

—— I am not including the unique village of Clovelly itself in this book – as such. It is well documented, having its own interpretive visitor centre. However, there is a close connection between Clovelly's New Inn (at which I have sampled atmosphere and a pub lunch on occasion) and this entry – through James Berriman.

James was landlord of the New Inn with his wife Mary and a keen disciple of the principle of model farms. He set one up at Highford, between Clovelly and Hartland, and began work there in 1878. Mary continued to run the New Inn.

One of Berriman's idiosyncrasies remains at a field entrance on the B3248 road (OS grid reference 302235), known as Berriman's Gateposts. Why James felt moved to record, on 10th January 1902, the cessation of the Boer War, the coronation of King Edward VII – with crown and cipher – and a strange verse on two gateposts, is pure speculation. One clue may lie in the lines:

'This field was once a common moor
Where gorse and rush grew free,
And now it grows green grass all o'er
As all who pass must see.'

Was Berriman trumpeting his own achievements, coupling them with a grand construction of central post, wall with curved top and smaller outer posts of rendered brick that nobody could possibly miss? From verses found on walls and even ceilings at Highford and New Inn, he was evidently addicted to composition.

James further embellished the central gateposts with two plaques; one is now missing. The other appears to show a man in armour. Earlier writers say that the words 'Charles Martel' appear on it; he was a Frankish king from whom Charlemagne was descended. It has also been suggested that the lost plaque depicted a woman's head in Tudor dress and 'Marie Martyr'. Was she Mary, Queen of Scots? Perhaps James Berriman had hidden Catholic sympathies.

The wording is very difficult to read, leading to misinterpretation. Alpha and Omega certainly feature as respectively 'first' and 'last' in Berriman's eulogies. He may well have been foretelling his own death in 1903 when he followed with the lines: 'And thou'llt be first for evermore, Now slumber on and rest.' Mary survived her husband by nine years.

🌿 CLYST ST MARY

——— The oldest surviving bridge in Devon stands here, isolated from the dual carriageway between the M5 and roads to Sidmouth and Exmouth. It lies among meadows, bridging the river Clyst and an associated brook, with five arches and a 600 foot long causeway.

Two arches on the west side are believed to date only from 1310 when the original 1238 structure was substantially rebuilt. What history the bridge which led into Clyst St Mary village has seen, not least during the Western or Prayer Book Rebellion in 1549.

Insurrections in various areas around Exeter flared into rebellion as those from Sampford Courtenay and other hotspots closed in on the city in early August, only to be routed at Clyst Heath by John Russell's men. Clyst St Mary's long bridge was strategic; it was blocked by defenders as the only way to cross the Clyst to – and from – Exeter.

A family namesake of Sir Walter Raleigh is credited with causing Clyst parishioners to join the rebels, by ordering an old woman carrying her rosary to church to renounce superstition. Incensed by his orders she ran into the building crying that the King's men were coming and worked her neighbours into rage and rebellion. Mr Raleigh barely escaped alive and Clyst St Mary's bridge was blocked with a huge tree-trunk, while a gun acquired from a Topsham ship awaited Sir Peter Carew and his forces.

Fighting took place on 4th August 1549 against Lord Russell's army; the bridge held, due to its narrowness, until one John Yard of Clyst Honiton who knew the area rode along the riverbank and crossed by the mill at a ford, then hit the rebels from behind.

Clyst St Mary village lay in ruins once the Western Rebellion ended. Today it also lies in two parts, separated by new road systems, with school, shops and inn closest to the old bridge. It's worth strolling across – as many walkers and cyclists have done since its closure in 1961 – to admire the arches at close quarters and to reflect that had it not been an ancient monument Clyst St Mary's bridge would almost certainly have been widened and altered to carry today's traffic.

COLYFORD AND COLYTON

Colyford and Colyton lie a short walk apart. The second as its name suggests is a town, the former a village straddling the road from Exeter to Lyme Regis.

They are both on the tram route from Seaton; Colyford's tram stop has a fascinating green-painted 1866 cast iron stand-up – or urinal in modern parlance – beside what was once its railway station platform. Don't presume to use it if you get taken short,

however, as despite ornate birds' heads with overflow spouts emerging from each beak it no longer functions.

Continuing slightly uphill you soon reach Colyton, with its Norman crossing tower and the octagonal lantern on St Andrew's church intended as a navigational aid. The river Axe was once broad enough to create a haven for shipping here.

Two relics of self-sufficiency and countryside crafts make Colyton rather special, as a town probably better known for its grammar school which regularly takes top awards and high positions in national examination lists. At the bottom of King Street is Baker's oak bark tannery and shop, with a history of 1,900 years in the area. Two Roman tanneries, used to supply their armies, functioned here around AD 86. I dislike the term 'virtually unique', but that's the best way of describing the work of Andrew Parr and Peter Batstone, and Andrew's ancestors.

Why oak bark? It was discovered long ago that after skins were left in forest puddles beneath oak trees they cured and lasted better. 'Everyone else has changed from this method except us.' The process is long and interesting; unfortunately it's not a safe one for the public to watch, although small pre-booked parties are taken around from time to time. The senses can be titillated by a visit to the attached shop, filled with leather and sheepskin which look and smell gorgeous.

The scent of sizzling metal on wood is perhaps less appetising. At Wheelers Yard across the bridge towards Thornleigh the Rowland family function as traditional wheelwrights. Mike is from the fifth generation in the business; there was a wheelwright named Rowland here in 1812, and one Richard de Rowland made wheels for wagons carrying stone in 1340 to build Exeter Cathedral.

COMBE MARTIN

——— Claiming the longest village street in England, Combe Martin's two miles plus feature in 'Hunting the Earl of (Ty)Rone'. This 17th century legend became an excuse at Whitsun – now Spring Bank Holiday – for a good time in the guise of history. The Earl, said to have hidden in nearby Lady's Wood, is caught by 'grenadiers' and put on a donkey, facing backwards, before being 'ridden' to the sea at the far end of the village. Somehow a hobby horse also crept into the story.

The Pack O'Cards, former home of George Ley.

Whether the Pack O' Cards was one of many ports of call for revellers I'm not sure. It certainly is today during the annual re-enactment. Squire George Ley built this curious edifice after winning a huge sum when gambling in 1690. The four floors represented the four suits of playing cards, 13 rooms the cards in each suit. Fifty-two windows (a few less nowadays, partly due to Window Tax) echo the number of cards in a pack. It is also said the building had 52 stairs and covered 52 square feet. Squire George's library window on the garden side had 13 panes of glass. The house was the Ley family home for about 100 years. In 1752 son George added a sundial on the side nearest today's car park.

The Ley family had left the premises, which became the King's Arms, by 1822; Jane Huxtable was landlady. Audits for lime and manure were held here; Combe Martin had kilns on its beach from the early 17th century to deal with lime quarried in the area. The inn hosted the village court; there is still a hook in the bar wall enabling division into a court, should it ever be necessary. Early livestock sales were conducted in an adjoining meadow; the Coneybeares (landlords 1878–1919) provided market lunches.

The name Pack O' Cards had been used by locals – even The Pack – long before it officially adopted the name in 1933; a hotel with full-size tennis court and putting green replaced the former coach stopping-place.

In the Oak Room, restored by the Furnifers who rescued the derelict building in 1991, Marie Corelli wrote *The Mighty Atom*. George Ley's crest – a lion on scabbard – still adorns one of the ceilings. A small museum of the Pack O' Cards' history shares the skittle alley in its pleasant garden.

COMBPYNE AND ROUSDON

Each village had several names during their long history, shown on a parish map made in 1999. They are separated by a little less than two miles; both feature in Domesday as manors held by Odo, then by Coffins and Pynes, Petres and finally by Peeks.

It was at Rousdon that Sir Henry Peek of the tea-rich family who originated at Loddiswell built his mansion and estate, later to become Allhallows College – currently in the process of development. Both villages benefited from Peek influence and benevolence. A school built at Rousdon in 1872 was the first place to serve school dinners – at one penny per meal. The present Dower House Hotel was part of the Peek Estate, built in the 1880s for the rector; after the estate split up in the 1930s, Allhallows' headmaster lived there. Peek also instigated the Verse Club for his villages, allowing children to gain a farthing for each correctly repeated verse; this payment went into a fund which eventually got them a pair of boots.

Down in the village of Combpyne is the manor whose rent was once a pound of cumin to be paid 'at the Nativity'; 13th century areas have been found inside the property. 'A lovely place to live,' says one of its present inhabitants, even though it lost its thatch, along with all the village, under Peek ownership. Manor House and Farm, once one property, is now two.

Opposite the Manor House is a curiosity with medieval associations. Named 'The Harbour', one might mistake it at first glance for a glorified duck pond. This has been man-created, harnessing the existence of a spring – or springs. The Harbour is only one of three original ponds; the top one now has a modern

house, 'Harbour Close', on its site. The present Harbour is the middle pond and a third is now a field beyond.

One early rector, Walter Wynt, described Combpyne as a 'place of fishponds and vineries'. Today it's a quiet backwater, with a tiny but fascinating church dedicated to St Mary the Virgin, which hides some 17th century murals and a possible 14th century votive drawing. There is great interest in preserving history, especially that associated with the Peek era – just what I'm sure Sir Henry Peek would have wished for his protégées.

COMPTON

The golden age of exploration and colonisation was riddled with men from Devon, due perhaps to having coast on three sides of the county. Drake and Raleigh are the first names to spring to mind, closely followed by Grenville and Gilbert; surprise surprise, three of the four families were related.

In the small village of Compton on the road between Marldon and Ipplepen, not far from the seaside resort of Paignton, is a castle in the care of the National Trust. It appears unexpectedly in a Devonshire lane, like so many other houses with a history, this former home to Sir Humphrey Gilbert.

As step-brother to Sir Walter Raleigh it's not surprising that Humphrey Gilbert became an eminent circumnavigator in the reign of the first Queen Elizabeth. He was also much interested in university education and wanted to establish a Queen Elizabeth Academy, submitting a proposition to her in 1572 – without result.

Gilbert suffered frustrations; brother John, of Greenway on the river Dart (recently connected with Agatha Christie) insisted he fulfil his duty by fighting in Ireland and Holland, and becoming a Member of Parliament. Humphrey's first idea for an expedition: to find a north-west passage to Cathay, proposed in both 1564 and 1566, was probably gifted to Frobisher some years later. In another expedition in 1578 aimed at colonisation he was attacked by Spaniards.

At length in 1583 Sir Humphrey Gilbert proudly planted an English flag in Newfoundland, only to die in the Azores on the homeward voyage in his ship *Squirrel*, with one of those dying

quotes that is never forgotten. 'We are as near to heaven by sea as by land,' Gilbert reassured his storm-tossed crew. Not quite what they wanted to hear, I suspect.

Why such strong fortifications for a family home? The Wars of the Roses and a tendency for the Bretons to invade the south and east coasts of Devon in medieval times are the most likely reasons. Compton Castle's H-shaped building – with five towers, solar and old kitchens – and the restored Great Hall and rose garden are open on Mondays, Wednesdays and Thursdays between April and October. Travelling from Marldon roundabout, it's just past Castle Barton restaurant, where you can park if the narrow road is congested.

COPPLESTONE

——— I've driven past the Copstone or Copelan stan, as it was first recorded in an AD 974 charter, more times than I care to count and often wondered about its origins.

This is really a cross shaft which once stood at the intersection of roads from Barnstaple, Crediton, Okehampton and Morchard Bishop: 'once' because it has been moved during its long tenure, most recently about ten yards north by Devon County Council in 1969.

This now places the stone on a relatively new plinth on a triangle of land where the A377 meets a minor road from Newbuildings outside Copplestone's post office and stores. It is most probably Saxon; remains of scrollwork can still be seen on the four sides, each divided into three panels. On the upper panels of the north-east face is a faint carving of a rider on horseback and an embracing couple. Sometime after its completion small niches were added, presumably to contain images of religious significance. A new information board tells passers-by that the Copstone was transported nine miles (or 15 km in new money) from Dartmoor, suggesting a deeply significant role. In summer troughs of flowers rest around the plinth.

Why was it brought here? The most popular belief is that it was raised around AD 905 as a memorial to Bishop Putta, possibly the mounted figure on one face. He was travelling between Crediton and North Tawton in his capacity as Bishop of Hereford when attacked and murdered.

Both the village and an old family have been named after the Copstone, although it's acquired an extra 'p' somewhere in map-makers' transcriptions. The Coplestone family had estates in the area by Henry VIII's reign, using their name for the large house deserted in 1659 and bought by Robert Hodge. He rebuilt it on a new site; the present version is Georgian and not very notable.

Devon County Council's engineers are lucky to be alive after their 20th century re-alignment of the Copstone. In King Edgar's charter of AD 974 it states that anyone removing the stone shall be 'stricken with a perpetual curse, perish everlastingly with the Devil' – 'unless he strive by reparation to make atonement.'

CORNWORTHY

How often do we see some ruins in a field and wonder what they once represented?

Cornworthy lies among rolling hills and narrow lanes near the river Dart; a clear view of the remains of its priory can be seen from the sloping village street. Home to between seven and ten Augustinian nuns from its foundation c1237 with the assistance of the Zouch family who held the Lordship of Totnes, it was dedicated to the Blessed Virgin.

This was the type of priory to which those of gentle breeding retired for convenience. Lay people were imported to do all the hard work. One of the early prioresses was Jane Fishacre, who died in 1334; Thomasina Dynham resigned after nine years in the position in the early 16th century and was succeeded by Avisia Dynham. A sister other than by religious profession? Avisia distinguished herself by being reprimanded by the Bishop of Exeter when he issued a 'mandate' – rather like military Part II Standing Orders.

Cornworthy's gatehouse was built a century or so later than the other buildings and was turreted. Two arches are still distinguishable: one for foot travellers and the larger for horses and carts. There was living space above reached by a stairway, and three windows. This gatehouse accounts for most of the ruins today although some of the west wall of the church remains. Mounds of grass mark where other buildings stood before the Dissolution, when Sir Piers Edgecumbe made

application for both Totnes Priory and Cornworthy Nunnery to Thomas Cromwell – and didn't get either.

Cornworthy was by then one of only three convents left in Devon. Prioress Avisia received a pension of thirteen shillings a year. In the second year of Elizabeth I's reign the site at Cornworthy went to Edward Harris and John Williams; it continued in the Harris family for several generations before devolving on the Bassett family, being sold to the Holditches in 1800.

To get a closer look, it's wise to take a turning towards Ashprington before reaching the village of Cornworthy from the west, or to drive down past Hunters Lodge Inn and Abbey Furniture at Court Prior in the village street; go up the hill beyond.

CREDITON

—— Winfrith – or should I say St Boniface – was born here in AD 680, probably in the area known as Tolleys, close to today's Mill Street. Boniface was a great Christian missionary and founding father of the Church in Europe. He is patron saint of Germany and Holland and is proudly claimed as the man who first invented our Christmas tree, when he confronted pagan tribes in Germany and cut down the sacred Thor's Oak. Pointing to a fir tree growing nearby, he told them to make Christ their light in the dark days (of winter) by taking him into homes built of the humble fir's wood.

At the top of High Street heading north is an area known as St Lawrence Green – you'll find it mentioned in the Town Trail for the large stone socket in its centre in which the town cross once stood.

On this open space – a former piece of waste ground where in 1874 bread rioters met to be harangued by a man called Martin before marching on food shops, needing 200 special constables to control their desire for affordable bread – fairs and other gatherings have been held. Crediton or Kirton St Lawrence Fair in mid August dated from 1232, famous for leather, wool yarns and cloth. It was also well known for its boxing booths and wrestling rings; the final day was marked – or do I mean marred – by bull baiting on St Lawrence Green.

Gardens were laid out here to mark Queen Victoria's Diamond Jubilee in 1897; I expect Mary Ann Rosslyn wished for formal gardens rather than a lonely patch of waste ground when she was seduced on St Lawrence Green during the Napoleonic Wars. Her betrayer was a young French officer held in Crediton as a prisoner of war who persuaded Mary Ann to elope with him to London when hostilities finished and abandoned her. She returned to Crediton according to local legend to find her father dying and 'mother soon to follow'. Unable to face these tragedies, Mary Ann Rosslyn drowned herself in the river Creedy.

Whence the name 'St Lawrence'? From a nearby chapel, dating from 1200 when it was used by an anchorite, or religious recluse, as a 'reclusorium'.

🌿 Cullompton

——— Take a stroll behind the main street at Cullompton, starting at Station Road, and you'll discover what once made the town tick. Mill Leat, diverted from the river Culm to power the mills of one of many Devon woollen towns, crosses beneath this road before following a public footpath.

John Lane was one of Cullompton's richest clothiers; Lane's Aisle in St Andrew's church (which you can see towards the lower end of Mill Leat footpath) is fan-vaulted, with much tracery, to trumpet to the world just how wealthy Lane was, displaying symbols of merchant ships and shears traditional to the cloth trade.

Higher Mill, still tall and very mill-like in its appearance, is now a private house. The mill sluice, both audible and visible, remains with some of its mechanism beside where the leat is bridged. Middle Mill's legacy is small; a sluice exit and part of one wall mark the building taken over by Thomas Bilbie's Bell Foundry when its days of milling ended. The mills had already turned from wool and cloth production to corn or papermaking.

Behind St Andrew's church in an area popular with dog-walkers the leat borders a pleasant open area with seating and even picnic tables before Lower Mill – believed to be the last worked in Cullompton – is reached. Once again it has become someone's home, but mill sluice and various metal supports and

controls are under its first floor balcony; the tunnel under which water entered the mill can still be seen.

On Cullompton's main streets, Fore Street and High Street, there are two areas redolent of its agricultural past – Lower and Higher Bull Ring. Near the former is Cockpit Hill, obviously used for cockfighting in centuries past.

Several buildings, in Fore Street especially, have lengthy histories and connections with Cullompton's wealthy past – and the mills. The Elizabethan Walronds, Veryards and the Manor House – the last two now form one hotel – are perhaps most interesting. A shell porch over Manor Hotel's doorway is typical of additions made in 1718 to Thomas Trock's original house of c1603.

DALWOOD

This village was in the neighbouring county of Dorset until 1842, although surrounded by Devonshire – which made it very useful for Dissenters; preachers could slip across to Kilmington (in Devon) if the soldiery came.

Dalwood lies between two ridges of the Blackdown Hills, in the valley of the Corry Brook, tributary of the river Yarty which itself joins the river Axe. It is remote but attractive; the medieval Tuckers Arms inn, still with its old bread oven to the right of today's entrance, was probably used to house workmen building St Peter's church, whose churchyard yew dates from around 1745. The manor's 14th century fairs charter, granted to Robert de Chauntemerle, was held for one quarter of a knight's fee and the duty to attend Feudal Court every three weeks; the event has its essence in today's popular village fair.

On the edge of Dalwood parish are two interesting properties; one, Loughwood Meeting House, is owned by the National Trust. The chapel was once in a wood – just as well since the Baptists it served were not supposed to meet for worship – and built in the 1650s. The other noteworthy building was once Baggaton Inn, whose landlady Mrs Newton was related to Beer's notorious smuggler Jack Rattenbury. If Revenue Men were expected, goods were swiftly moved across the Baggaton's yard into neighbouring Stockland parish.

Why should a headstone to the son of Portugal's Prime Minister Jose Travassus Valdez, Count of Bomfim be found in

Dalwood's country churchyard, close to the south door? Pedro de Alcantara Travassus Valdez, sixth son of the worthy count was, it seems, a simple soul – termed a 'natural' in the 19th century. The stone claims that his father was aide-de-camp to the Duke of Wellington in the Peninsular Wars, which might explain an English connection. (History actually records him serving the commander of Portuguese auxiliary forces.)

Pedro came to Dalwood to be cared for by the Edwards family, and moved to nearby Danesfort when Mr Edwards retired as village postmaster, until his death in 1887. Though 'harmless', he presumably could not be acknowledged by a father in a lofty position. His headstone, tellingly, has as its epitaph 'Blessed are the pure in heart, for they shall see God'.

DARTMOUTH

The second and third Crusades left here in 1147 and 1190 – which led to military and commercial use of the Dart estuary. Dartmouth's a town of two river settlements: Hardnesse and Clifton, once separated by Mill Pool. Chaucer came here in 1373–4 and probably found the model for his *Canterbury Tales* Shipman in shipmaster, merchant, castle builder and later Mayor John Hawley. It's a place of castles and cannons – like the Russian Crimean War trophy on South Embankment, cast c1826 in Briansk – batteries and bulwarks.

You name it in trade, Dartmouth had a hand in it at sometime. It also bred the man who produced the first industrial steam engines. Thomas Newcomen, baptised in 1664 and later apprenticed to an Exeter ironmonger, had a business in Lower Street. He developed an engine to pump water from Cornish tin mines in around 1712 – the beginning of practical thermal prime movers in industry – or so textbooks say. It used the principle of condensing steam by cold water in a cylinder to create a partial vacuum; atmospheric pressure did the rest.

Behind Dartmouth Tourist Information Centre in Royal Avenue Gardens – close to the Boat Float (land-locked except for a short period at high tide) – is an example of Newcomen's work. Not his first version, which went to Dudley and is replicated in the Black Country Museum, but one from Griff Colliery, Hawkesbury, brought here for Newcomen's tercentenary in 1963. And it works!

In 1921 a group of supporters managed to make up for the fact that Victorian councillors' arguments had prevented the seafront gardens being named after Thomas Newcomen by placing an obelisk there, with a copper engraved plaque showing a beam engine. The council obviously weren't worried about his former premises either. While building a retaining wall and new road they knocked them down. Ironically the road was then named after Newcomen and a plaque hung on the wall in Lower Street to explain what formerly stood there!

Fortunately they haven't taken similar action elsewhere or Dartmouth wouldn't have the richness – no, largesse – that it has of wonderful old buildings behind its ever-popular waterfront.

DAWLISH

Dawlish lies on the stretch of coast immortalised by early 20th century railway posters; the line from Starcross to beyond neighbouring Teignmouth runs between the sea and red sandstone cliffs. Its name comes from a freshwater course, 'dolfisc' or 'black stream' in a 1044 charter, which runs from Aller Hill past council offices at the Manor, where it becomes Dawlish Water.

John Edye Manning is credited with landscaping ground between Dawlish's original inland village and the stream and breaking it up with artificial waterfalls, from 1803 onwards. The first gardens were called Tuck's Plot, after a baths owner who grazed his horse there (without permission). In 1810 disastrous floods made it necessary to turn the brook into a canal. York Gardens came into being in 1899; today most people call the area crossed by bridges, attractively lit at dusk, the Lawn.

Houses on the north side formed the Strand, where Jane Austen and Charles Dickens both stayed; Nicholas Nickleby's birthplace was Dawlish. In the brook's upper reaches stone walls can be seen together with 'Fishing Prohibited' signs. Even then brown trout which lived here were being plundered.

Nowadays it's a pity that seagulls can't read – they're the most likely culprits. They are also inclined to attack small fry near the hatchery in Brunswick Place, where many of an amazing variety of waterfowl come into the world, including the famous Dawlish Black Swans: *Chernopsis atrata*. The first pair of these birds

One of the famous Black Swans (chernopsis atrata).

arrived in around 1906, so the Swan Inn in Old Town Street predates them, taking its name instead from wild swans nesting in the marshes. It's an interesting hostelry, with a list of landlords and landladies from 1661 in its bar.

Uganda game warden Captain C. R. S. Pitman gave Dawlish a second pair of Black Swans after the Second World War in memory of his parents who lived in the town. The birds have had chequered lives ever since; despite a waterfowl warden the young have several times been killed or injured.

A Black Swan is a distinctive and compelling sight anywhere; sailing majestically along the waterway in a seaside town which adopted it as its emblem, the bird is another example of the diversity that is Devon.

DOWN ST MARY

Turn off the A377 north of Crediton to Down St Mary, and you'll find a small village clustering around a crossroads. It has a church, houses, farmland – and a rare modern example of an ancient craft.

Down St Mary's bus shelter, built on a large triangle of land, has been created using the traditional art of cob walling. This technique employs stone rubble as its plinth; walls are built up gradually in 'lifts' or 'raises' without shuttering, from a mixture of subsoil (or dung), straw and water. 'Cob' comes from the Old English and means 'limp or rounded mass', which describes its production and deployment well. The mixture is heaved and trampled – either by foot or more recently using a tractor – before creating a lift and letting it dry out, then shaping. Summer is the best time to build in cob: between swallows' advent and departure for southerly climes is Devon tradition.

The result is frequently painted in pastel shades. This building is white. Local builder Mr A. M. Howard decided in 1978 to prove that the old craft was still practicable; he has certainly succeeded. Unlike many Devonshire cottages of similar material it is not thatched; the roof is of wood inside, covered with tiles. Above the ridge a weathervane depicts a large bell, about to be struck.

The motto 'quid nobis ardu' (approximately 'which was difficult for us') on the bus shelter's lintel is matched by a plaque confirming its building and presentation to Down St Mary parish by the Howards in 1980. Shrubs and bulbs have been planted here by parishioners, including several in the trough of Bushell's Pump, also restored and re-sited here in 1980. With a small parish noticeboard in place, the Howards have created a focal point for the village.

Worth a detour to see it? I think so.

DUNCHIDEOCK

The first time I took visitors to Topsham, on the river Exe, one of them gazed across to Great Haldon and asked, 'what's that white castle up there?' It's actually Palk's folly – known as Lawrence Tower or Haldon Belvedere. Many people will have

seen it in their travels south from Exeter; relatively few know its story or where to find it.

Haldon Belvedere lies close to the villages of Dunchideock and Kenn, off the A38 and can be climbed on Sunday afternoons – more often in high summer – and its first floor ballroom is now a chic place to be married.

Sir Robert Palk (1717–1798) discarded life as a clergyman for the Civil Service in India, rose to the heights of Governor of Madras and in so doing amassed a fortune. Making the peace in Hyderabad probably contributed to his baronetcy in 1772; he purchased Haldon Hill House – now the Lord Haldon Hotel – from Sir George Chudleigh in about 1768, with 400 rooms and acres of forest and moor attached.

Palk's work in India brought him into contact with Major Stringer Lawrence, founder of the Indian Army. Their admiration was mutual; Stringer Lawrence was made welcome at Palk's home. When Lawrence died in 1775, the baronet discovered he and his family were Stringer's heirs. In gratitude he had a folly, presenting twin towers across the Exe, erected to remember him. On the ground floor was a stone statue of Major Stringer Lawrence in the guise of a life-sized Roman general, with laurels.

The building's likely inspiration was Isaac Ware's Shrub Hill Tower in Windsor Great Park; others in Devon had emulated it, like Powderham, just downriver. The Palk family used it to host dinner parties and dances.

A Palk descendant, one of the Lord Haldons after whom the hotel is named, gambled away the estate during the 19th century. The Dale family – Annie and her sons Edward and Cyril – bought it in 1933; they lived here until the latter brother died in 1992. By then it was a virtual ruin with socks and old sheets stuffed into window frames. Restoration by English Heritage and others came in the nick of time. The view above its 99 spiral steps is stupendous on a clear day.

 ## DUNKESWELL

See **Hemyock** and **Dunkeswell Abbey**.

EXETER

Exeter is an amazing place. Uncover its history as you will; there are so many layers from which to choose. Some are literally buried – like the underground passages that carried its early water systems. And you can shop surrounded by parts of its Roman walls.

The City of Exeter, which by contradiction is Devon's county *town*, is still filled with churches, from remnants of ancient

Matt the Miller clock, St Mary Steps church.

St Nicholas Priory to the aptly named St Mary Steps, hidden behind Fore Street alongside Stepcote Hill – part of the street up which people passed, via the West Gate, from quay to city centre from Roman times until around 1778.

On the south-west tower of St Mary Steps church is a timepiece known for centuries as Matthew (or Matt) the Miller clock. It is generally presumed to be from early in Henry VIII's reign with the central figure intended to represent the king, and two escorting 'jacks' or javelin men flanking him. On each hour Henry – or Matthew – nods his head as a bell is struck. At the quarter hour the jacks take turns to strike bells at their feet. Below an elaborate carved alcove containing these three figures the clock face has a dial surrounded by carvings of the four seasons.

Today one henchman has lost his head; the central figure has been replaced at least once and wire mesh protection is necessary to prevent further damage to what was essentially a 'parish clock'. James Taylor and Matthew Symons, Churchwardens of St Mary Steps, are credited with its erection; a dispute ensued over who did most towards its cost, with Taylor setting up the clock, made by another Matthew (Hoppin), and dial and Symons providing the statues and bells.

Whilst nobody has entirely proved Matthew the Miller's existence, very few of Exeter's inhabitants down the centuries believe he didn't inspire the clock through his punctuality – you could 'set a clock by him' – on daily journeys from his Cricklepit Street mill into the city.

'Matthew the Miller's alive, tho' Matthew the Miller's dead,' says an apochryphal rhyme; 'For every hour, on the West Gate tower, Matthew nods his head.' And the jacks? Who else but the miller's two sons. A packhorse and mill set among trees were also carved there until the clock's last updating in 1980. As seems to have been customary, the names of St Mary Steps' churchwardens are carved beside Matthew the Miller clock, sited opposite one of the most famous removals in history. The 'house that moved', another piece of 16th century Exeter, was mounted on rollers and shifted, to allow construction of a new road complex in the mid/late 20th century.

Exmouth

Here's a seaside town claimed to be the earliest in Devon; its size and appearance has altered beyond belief in the last 30 years. It is still changing, notably around the former docks. Two miles of golden sands, which shift from beach to promenade every winter, attract the bucket and spade brigade and water sports devotees, especially windsurfers.

Does Exmouth have anything else to offer? The best place to find out is in its museum, tucked up Sheppard's Row off Exeter Road, near the town centre. Converted from an old council stables and foreman's cottage, it has been described as 'the town's collective attic'. Spare a thought for the volunteers who turned the stables and loft into a museum from scratch after waiting over ten years to fulfil a dream.

Everything from lacemaking in the town to the wheel from the Russian schooner *Tehwija*, which ran aground off Orcombe Point in 1907, is packed into this tardis-like building. Exmouth Museum offers a Town Trails booklet to help visitors find Lady Nelson's former abode on The Beacon, the only thatched property in the town centre, or the Maer nature reserve, aided by blue plaques on notable buildings supplied by the Exmouth Society.

To discover where Lady Nelson, her son and several of his children were buried in 1831, you will need to visit one of Exmouth's 'suburbs' – the village of Littleham. Her tomb lies in the south-east corner of St Margaret & St Andrew's churchyard, easy to pick out by its surrounding railings.

Lady Nelson had her family exhumed and brought back by sea from France in 1830. Reasons for their premature deaths vary: from illness to being caught in a Bourbon uprising in France. It is well documented that they arrived late one evening and were lodged overnight in a newly built castellated property on Exmouth's Morton Crescent, giving it an unwelcome reputation and the name 'Corpse Castle' during its short life.

Don't confuse this Littleham, as Devon's press did in the mid 1990s, with Littleham near Bideford. Great excitement ensued when Exmouth people believed the Lordship of its manor was up for sale, only to discover it was the one in North Devon.

FILLEIGH

Driving around minor roads between South Molton and Barnstaple is always rewarding; Stags Head Inn east of Filleigh for example: long, thatched and evidently popular at lunchtime with those 'in the know'. The unusual name of this North Devon village is thought to derive from St Fili, to whom a Celtic church here was dedicated.

Much of the land in these parts has been owned by Fortescues – some from the 15th century; in the 17th they replaced the family seat at Weare Giffard with a mansion near Filleigh called Castle Hill. Arthur Fortescue and his son Hugh first enlarged the house in the 1680s; it was the second Hugh, who, aged only 26 years, succeeded to the Clinton barony through his mother and became the first Baron Fortescue in 1746, who created an 18th century country mansion on a grand scale. When a 'second Domesday' was recorded in 1870, the Fortescues were second largest landowners with a seat in the county.

Castle Hill is a wide-fronted house faced in Portland stone, whose green ball-topped dome and long nine-bay wings can be seen from the road through Filleigh's small village. There are water meadows in front, lawns and topiarised trees. Many of the ideas used were gleaned by Hugh from extensive travels in France and Italy. Large-scale reconstruction of Castle Hill's interior took place in 1935 after a major fire; its exterior remains largely 18th century.

Behind Castle Hill the land rises past a garden summerhouse; what more natural than to place at the top a triumphal arch – or sham castle? Made of old stone, castellated, with towers at either end, it was intended to furnish a vista from the house itself.

In the 1840s another Lord Fortescue decided to carry a road up to the arch; lack of maintenance during the 20th century almost brought the arch down in 1961 due to the weight of ivy covering it. Family, tenants and friends had it rebuilt in memory of the fifth Earl. Reaching the arch is possible from footpaths over Oxford Down, on the other side of the hill.

There are still Fortescues here; Castle Hill is currently home to the ninth Earl of Arran whose wife is a Fortescue heiress.

 FRITHELSTOCK

Rare remains of a North Devon religious house can be found in this quiet village. They lurk furtively behind St Mary & St Gregory's church, so close indeed to the north-east corner that I can't help feeling the priory's south tower must have touched it.

Under the church lychgate is a ceramic plaque, part of the *North Devon Alphabet of Parishes* like Atherington, Molland and others. 'Y is for Priory', it says, with examples of Frithelstock life past and present. Follow the lime trees – 14 like Christ's 'Stations' from Jerusalem to Calvary – to the church door and turn right, to find the remnants of Sir Robert de Bello Campo's

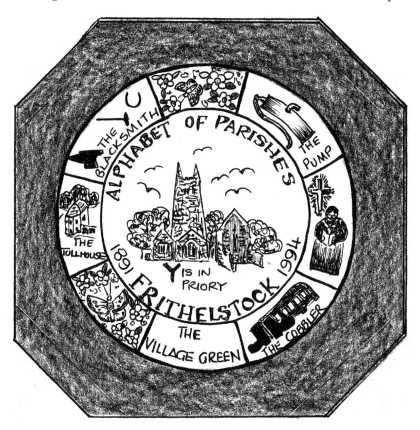

'Alphabet of Parishes' plaque, under church lych gate.

priory of Augustinian canons, colonised from Hartland Abbey by a prior and four canons c1220.

It's no longer possible to walk round the long wall with pointed archway and lancet window arches of a former 89 foot by 23 foot building unless you ring the number on a sign (remembering to put a 6 before 23163 in deference to Torrington's current phone system) and make an appointment.

Even at a distance the mound marking a high altar, a great tower standing in front and to the left and a Lady Chapel beyond can easily be imagined. There were priory lodgings where nearby farm buildings now stand; excavations in the last two decades revealed cloisters, refectory and a main entrance in the west wall.

Richard de Bittendene (a 14th century prior) was a poor manager who fell foul of Bishop Grandisson of Exeter. He placed a statue in the priory's new chapel which neighbouring parish priests believed to be of Eve or, even worse, Diana, goddess of the chase. The bishop sacked de Bittendene, ordering the chapel be razed. Look at the ancient pew end in the choir of St Mary & St Gregory's – north side; two medieval clerics stick out their tongues at one another. They represent the two protagonists. Who said medieval sculptors had no sense of humour?

🖤 GEORGEHAM

—— Pilgrims visit Georgeham annually; I hope they all arrive via Saunton Down and Croyde and have their eyes gladdened by views beyond the Taw and Torridge, and the Croyde thatch.

Henry Williamson, writer of *Tarka the Otter* and *Salar the Salmon* etc, lived in the little village of Georgeham from 1921 to 1929, often in poverty. When he returned to Devon around 1948, having made some money, he built a hermit's hut in a field above Georgeham, where he used to write.

His grave is in St George's churchyard at the west end near its boundary with a stream. The stone is of plain slate – its only ornament an owl – simply engraved 'here rests Henry Williamson 1895–1977'. President, officers and members of the Henry Williamson Society visit annually and lay a poppy wreath. They continue to Skirr Cottage, one of three thatched terraced properties beyond the stream, and an added-to stone

built house with slate roof, now named Crowberry Cottage. A blue plaque records that Henry lived here between 1925 and 1929 and wrote *Tarka the Otter* (published in 1927).The final visit is paid to Ox's Cross, to see the hermit's hut.

The Williamson – or rather Tarka – Trail pops up all over North Devon, including Weare Giffard, near where Tarka's birthplace is well documented. The journeys of Tarka between the rivers Torridge and Taw, more than any of Henry's other animal characters, have given rise to a 180 mile trail from mid-Devon to the north coast, even including a stretch of railway line. Parts of it make an excellent way to explore on foot or by bicycle.

St George's churchyard has another gravestone of interest. Inside the lychgate on the left, behind a small cross with steps, the following is recorded: 'In loving remembrance of PC Walter Creech, who died in the execution of his duty, aged 31 years, in 1883. "Ye know not what shall be on the morrow"'. Walter could hardly have known when he went on duty he would be stabbed to death by a drunk. In a further twist to the tale, the man cheated justice by dying – of drink – on the very day he was due to stand trial.

GITTISHAM

Devon is – or perhaps I should say was – famous for its apples, so it's hardly surprising to find oneself tracking down Tom Putt in this lovely village of typical Devonshire thatched cottages, and finding he gave his name to a variety noted for its all-round qualities. It's one of the old cider and culinary apples of Devon which Thornhayes, among other nurseries, can still supply (telephone: 01884 266746).

Sir Nicholas Putt bought the estate at Combe, whose house is now an upmarket hotel, in 1615 from Sir Thomas Beaumont, who didn't care for the Devon air. The family lived here for around 200 years, when it passed into the Marker family by marriage. If you're keen on family memorials there are plenty in St Michael's church.

A window at the west end of the south aisle by a carved box pew is a good place to spot another of Tom Putt's communings with nature. 'Black' Tom Putt (also a Somerset variant on the original apple), known for a violent temper, planted a beech

avenue in around 1780 up Bellevue – sometimes called Baal's – Hill. A candle was kept in St Michael's west window to appease this pagan god. Putt chose beech trees, being unfit for working in wood, 'so some fool would not want to cut them down,' and extended his efforts to create a plantation of them.

Tom Putt was a Middle Temple Bencher, son of Raymundo, who knew the value of education. Cottages on the triangle outside St Michael's churchyard, bearing the same name, were a Putt family school from 1720. The school was given to the poor of Gittisham 'that reading, writing, arithmetic, navigation and the catechisms might be taught'. Navigation was included in recognition of Devon's seafaring traditions – although the pretty village brook hardly challenges such skills.

Gittisham was also the birthplace in 1750 of Joanna Southcott, styled the 'Bride of Heaven'; she was baptised at Ottery St Mary. Joanna tricked over 140,000 people into joining her Society.

I doubt whether she'd have impressed Black Tom Putt.

GREAT TORRINGTON AND TADDIPORT

Markets, glove making, dairy products and crystal glassware have been some of Great Torrington's claims to fame. Fortunes come and go here; they went with a bang in 1646 when the Roundheads imprisoned large numbers of Cavaliers in the church, which the king's men had been using as a powder store. Someone created a spark and … poof!

Great Torrington has finally exploited its past with a 1646 themed experience, making, with the nearby RHS gardens at Rosemoor and Dartington Crystal works, a tourists' dream of a day out. I wonder how many who arrive at Castle Hill and peer over the precipice to the river Torridge below realise that the town is nicknamed 'the English Jerusalem' for this panoramic view?

Further along the river valley are the remains of a leper colony: one of at least four I've discovered as an 'Incomer' to Devon. The former chantry chapel of St Mary Magdalene lies just beyond an old toll house in the hamlet of Taddiport. A small square building, with embattled 5 foot tower, it was recorded as part of the 1310 leper hospital by 1418. Its first chantry priest, Sir Richard de Brente, is mentioned in 1311.

The chapel is in use as St Michael's church, with some original features and restored paintings of the Ten Commandments in the 16th century style on its east window. The hospital ownership was conveyed to the mayor and burgesses of Great Torrington and the churchwardens of Little Torrington; in the late 17th century it fell into disuse for 'want of lepers'.

Even more fascinating – not to say unusual – are two remaining strips of Magdalene lands rescued by Mr I. McKinnon, restored and given to Great Torrington Town Lands charity in 1970. These were originally seven, tilled by lazars on the Taddiport bank of the Torridge. Long, narrow strips of bright green, bounded by hedges can be seen either from Castle Hill car park or whilst returning from Taddiport via the Millennium Path on the Torrington bank – a pleasant way to retrace your steps.

Why Taddiport? Possibly from 'Tadige-pytt' – toad pit or toad port. The first suggests contempt for its poor inhabitants; toad port, using port in the sense of market town, perhaps refers to its proximity to Torrington and the occasional seasonal plague of toads or frogs from the river.

HALWELL

——— A 'forgotten village' must surely be a candidate for this book. Halwell is not strictly forgotten; its heart was simply ripped out in the late 1960s to straighten dangerous bends on the A381 Totnes to Kingsbridge road. In the process eleven old cottages, a bakery and post office vanished under a grassy bank which rises across the main road from St Leonard Abbot's church.

Sadly Halwell's loss continued with its school – gone by 1974 including the building. For a village that once supported vet, carpenters, tailors, monumental masons, shoemakers, smith and three inns, as well as those businesses previously mentioned, this must have seemed a body blow. Only one of the inns remains, known as Old Inn and covered in creeper.

Halwell was among Devon's four 9th–10th century 'burhs' before it was succeeded by Totnes. The Iron Age fort above the settlement is thought to be where Alfred's troops once assembled near a prehistoric ridgeway. Its manor was held first by Halgewicks, then by Verneys and Hales – history indeed!

One relic of the old village is its church where a cross inside the churchyard gate has a less than ecclesiastical history. Until 1935 Halwell had a whipping post which stood outside the church grounds – a red telephone box now marks the spot. Very elderly parishioners have described members of St Leonard's congregation tethering their horses to the old whipping post. Nobody ever suggested, said one old lady, that this had been their village cross. Why it was moved inside the lychgate is unclear; what is evident, however, is relatively modern cement, welding a cross which looks newer than its shaft.

The final irony for villagers who remember Halwell's 'forgotten' area of village must surely be the rash of modern properties beyond the bank which swallowed up those old cottages. I believe they call it in-fill development.

HARBERTONFORD

A busy village, divided by the A381 road from Totnes to Kingsbridge and also by the Harbourne, which is given to flooding. Harbertonford was known for its mills; several grew up along the river's banks. One was still a woollen mill in the 1950s – the fast running Harbourne must have been excellent for fulling.

Close to St Peter's church on the lane to Diptford are several converted mill buildings whose three and four storeys have mostly become homes with patio gardens behind. A foray into their car park gives a clearer view of the old mill properties, with archways, metal beam ties in walls and evidence of doors where sacks were once hoisted. Round a corner is another old mill still awaiting conversion. Names like Mill Cottage and Teasel have sprouted on nearby cottages in recognition of the area's past.

Another type of mill lies along the valley which leads via Old Road to Tuckenhay and Bow Bridge – both scenic tourist spots. Crowdy Mill is an 18th century stone and slate watermill, still in working order and only prevented from producing stoneground flour when water problems upstream make it impracticable to supplement its other use as a guesthouse.

Past a central area beside the church, post office and stores and an upmarket restaurant and over a bridge, Harbertonford village continues along the road to Moreleigh, mostly slate roofs over

stone or rendered walls. It begins to rise in narrow lanes towards a village hall and football ground. Look across the latter and the busy Harbourne to the old mills, for the best impression of how they looked in their heyday.

HARTLAND: STOKE

——— And so to the remote and often wild area of north-west Devon known as Hartland. The village is slightly inland from the coast with craggy cliffs leading in turn to the ancient abbey, to Stoke and to Hartland Quay.

St Nectan is patron saint of Hartland parish and of its church at Stoke. He features hugely in north-west Devon churches, having died a martyr's death in the area, after arriving from Wales in the late 5th century as missionary to Devon. A well about 100 yards from St Nectan's church is the reputed site of his hermitage.

Countess Gytha had her collegiate church here before 1053. The Countess married Earl Godwin, who held Hartland as a royal manor; it is believed she built the church in thanksgiving for his escape from shipwreck. Shipwreck – or avoidance of it – may also explain St Nectan's tower, highest in North Devon and built in the 14th century partly as a seamark on Hartland's treacherous coast.

In the north aisle are plaques, mostly on slate, to the Lane family including Allen Lane, founder of Penguin Books, and his father John: 'Publisher of London and devoted son of Devon, 1856–1925'.

St Nectan's also boasts one of the largest and finest rood screens in Devon – 15th century, of oak, and little restored – and a swivelling lectern to hold two Bibles, although my main reason for including this church was its Pope's Chamber. Built over the north porch and reached by steep stone steps inside the church, the small room has a fireplace. It contains pieces of the Jacobean pulpit of 1609 (cost thirty shillings) which was re-carved on King James I's death in 1629, adding the word 'fines' – presumably 'finish' – after 'God Save King James'. Pre-Reformation, a priest or sexton lived in this small chamber; in Elizabethan and Stuart times the parish armour was stored here.

One final delight is St Nectan's lychgate. The gate itself is counterbalanced by a long tube on a rope, allowing the whole

contraption to swing through 90 degrees for exit and admission. I'll bet the Sunday School children have fun with it.

☙ HATHERLEIGH

The soul of this mid-Devon town is its market and the associated meat slaughtering company – as the nation discovered on its television screens during 2001, during the foot and mouth epidemic. A sloping main street with the George posting and coaching inn is buzzing on market days. Hatherleigh's livestock markets lie just behind it and the church, whose clock once struck the month and day after its five and nine o'clock chimes, a boon to those without access to newspapers – or who couldn't read.

I've heard several tales about the market, like the escapee steer which swam the length of the George's outdoor swimming pool

Bronze bas relief from the Morris monument.

– twice – to evade its captors. One night in 1998 visiting rugby supporters 'dead-headed' two of the farmers on Hatherleigh Market's Roger Dean sculpture (quickly reinstated).

More surprising is the discovery of another monument just above the town, to a hero of the Crimea. Lt Col William Morris, born at nearby Fishleigh in 1830, was a captain given command of the 17th Lancers when his predecessor died of cholera. On 25th October 1854 Morris led his men into the Battle of Balaclava: one of the regiments sent into the 'valley of death' in the Charge of the Light Brigade. Although wounded twice (and twice rendered unconscious) he survived to reach the Scutari hospital and the legendary Florence Nightingale. Morris recuperated in England, returned to the Crimea and by 1856 had become Lt Colonel.

Our hero met a tragic death aged 38 in Poona – from sunstroke. A silver plate inserted into his skull to repair damage inflicted at Balaclava is believed to have caused overheating. In 1860 public subscription paid for an obelisk on Hatherleigh Moor, close to Morris's birthplace. This area has its own tale, being by tradition given to the town by John of Gaunt:

'I John of Gaunt do give and grant
Hatherleigh Moor
To Hatherleigh poor
For ever more.'

The bronze bas relief on the obelisk's base, created by F. B. Stephens of London, shows Morris being carried from the battlefield. It may well be the frontage added in 1901 by Sir Robert White-Thomson in memory of his own brother, John Henry Thomson, and in admiration of William Morris's skills as commander.

HEANTON PUNCHARDON

Heanton Court, home to the Bassett family between the 15th and 19th centuries, is now a family inn on the banks of the Taw estuary.

The village of Heanton Punchardon lies inland beyond Wrafton. From St Augustine's churchyard is a panoramic view over RAF Chivenor (with its own village – of a sort) to the Taw

estuary. There are graves here of airmen from Canada, Australia and New Zealand based at Chivenor during the Second World War; beside a large holly tree at the south-east end of the church is a local grave with no-less patriotic connections.

Edward Capern has been styled the Postman-Poet. He was born in Tiverton in 1819 and moved to North Devon when 'learning the lacemaking' strained his young eyes. Edward became a French polisher, then a carrier in Barnstaple and Bideford, with a post round between Bideford and Buckland Brewer. As he walked, Edward made up verses, the first volume of which was published by William Rock when Capern was 37. *The Lion Flag of England* so impressed Lord Palmerston that he awarded Capern £40 annually from the Civil List to fund his writing. They gave him hope and strength to bear many of the country's greatest trials, said Palmerston. The verse was distributed to troops in the Crimea to boost their morale. To fellow poet Walter Savage Landor, Capern was the 'Burns of Devon'.

A sentiment with which the people of Clovelly agreed. When Captain James Braund of Bucks Mills saved two of their fishermen and their boat in 'a great storm' they knew exactly whom to approach for a poem, lauding Braund's efforts and intended to be printed and sold to purchase the Captain a new boat as a reward.

Edward Capern died in 1894; Poet Laureate Alfred Austin was moved to add a rather flowery poem to his tombstone. Capern's grave lies close to the estuary, beside his wife Jane who died less than four months earlier. His postman's bell is incorporated into the headstone, with a verse from Edward himself which sums up his philosophy:

> 'I'd be remembered for some word I said,
> Some thought immortal, winged with passing breath;
> But more for one true, tender-hearted bead,
> Since such sweet things the world doth sorely need.'

HEMYOCK AND DUNKESWELL ABBEY

Heading for Hemyock around Amen Corner on the road from Culmstock, don't be surprised to meet two ladies of uncertain age with their black and white pony and green painted

trap. We did; as it wasn't a pleasant day both were well wrapped against the rain.

To reach Dunkeswell Abbey pass Hemyock church and its castle, which William Asthorpe was allowed to fortify in 1381 and given a 'licence to crenellate' (which sounds slightly suspect). Resist the temptation to go no further; visit Hemyock's neat village on your return trip – if only to admire the village pump-cum-streetlight in its centre commemorating Victoria's reign, Edward VII's coronation and peace in South Africa, and see the ducks on Hemyock Castle moat and its castle pillory.

Through the lanes and up and down hill the road winds to Dunkeswell Abbey, its church, former school and cottage clustered around a small green with old village pump and red phone box (it's signposted, luckily).

Inside Holy Trinity church are plans and details of Dunkeswell's history, with a useful map of monastic Britain. I learned that William Brewer founded the abbey as an annexe to Forde on the borders of Somerset and Dorset around 1201. Twelve monks and workman Gregory were sent to build here. William himself was buried before its Great Altar.

Not everything went smoothly between church and laity. In 1384 Sir William Asthorpe (of Hemyock Castle) and his men rounded up the abbey's cattle and impounded them at Kennerley; the Abbot mustered 59 men, broke into the pound to reclaim his beasts and assaulted Sir William's servants. Richard II was forced to set up a commission to ascertain the facts. Lack of a result suggests that even then commissions weren't all they might have been.

Lord John Russell acquired Dunkeswell Abbey and the village of Dunkeswell after monasteries were dissolved. Most of its stone went to build other properties – an ad hoc quarry? The Simcoe family who pop up in Hemyock Castle's history in the 19th century cleared most of what remained to build Holy Trinity church in the abbey grounds. Several pieces of wall can be found with the gatehouse beside the church path; in the garden of a thatched cottage next door, other pieces hint at Dunkeswell's former glory.

HOLNE

Charles Kingsley was born at the old vicarage here, in the Dart valley, on 12th June 1819; his father was briefly curate-in-charge. There's a memorial north window in the church of St Mary the Virgin and the nearby 14th century Church House Inn has its Kingsley Room.

Bourchiers were lords of the manor of Holne in the 15th and 16th centuries – later Bourchier-Wreys. A Robert de Bourchier was Chancellor of England in 1341. Holne Park, their ancestral home, passed to the Dawson family in the 1900s.

In the churchyard an ancient yew whose hollowed out trunk is held together by huge metal pins is still capable of producing bright pink berries. The tree dates from the church's inception around 1300, so this fertility is pretty special. Churchwardens' Accounts of 1737 suggest one use for the tree in the 18th century: dead foxes were hung on 'the venerable old yew' as proof to farmers coming there to worship on Sundays that claims for rewards (of 10s 6d) for catching them were justifiable.

Above Holne before sunrise on May Day (originally on Midsummer's Day says one source) young men assembled to catch a ram on Dartmoor. They slaughtered it while secured to a menhir close to the village before roasting the animal whole. At midday the meat was cut off and all present ate some for luck. This tradition evolved into a ram roast and sports; today Holne still holds a country fair among some of the loveliest scenery in Devon.

The parish extends down alongside the river Dart to Holne Bridge near Dart Valley Country Park. There was a bridge here before 1413 when, the previous one having been washed away, archdeacons were told by their bishop to offer indulgences to any parishioners prepared to contribute towards a new one. The four-arched bridge resulted. Traffic can only cross singly even today. Pedestrians are better catered for; there are safety niches across its hump in which to shelter – providing you aren't too broad in the beam.

HOLSWORTHY

Holsworthy is an atmospheric Devon market town with weekly agricultural auctions. Trailers filled with sheep and cattle

toil up and down its steep street on market day, struggling through its oblong Square, where anything from fish to flowers sells on stalls that pack the area.

In the late 19th century railways finally reached Holsworthy; the livestock market's importance justified bringing lines as close as possible to benefit farmers and dealers alike. How were builders of the London & South Western Railway to manage the difficult terrain?

Their answers long outlasted the lines themselves. A stone viaduct of eight 50 foot arches was constructed around 1879 to carry a branch line 90 feet above ground level from Okehampton into Holsworthy station. Coles Mill viaduct is visible as you approach from Hatherleigh – now partly screened by trees and other vegetation. For a closer look, turn off Holsworthy's main street into Coles Mill Close and follow the road to the top. Behind new houses and bungalows its lofty splendour crosses the valley.

An 1892 viaduct known as Derriton supported the line's extension towards Bude in North Cornwall, reached in 1898. This used pre-cast concrete block construction, carefully marked to simulate masonry – the first viaduct to employ this method, it is claimed. With no less than ten arches 95 feet above ground, it boasts a view worth climbing to experience.

When the ever-friendly Dr Beeching closed Holsworthy's railway line in 1964 these viaducts were redundant and in danger of crumbling. Derriton has fortunately been preserved as part of an established cycle route (Minehead to Padstow),

Derriton railway viaduct.

reached off Holsworthy Square, on the road to Pyworthy. A newly-completed ramp leads onto it, which is fortunate for lovers of railway architecture as the other prime viewing spot is about to vanish behind yet more housing. Coles Mill viaduct will soon be added to the route, as part of the North Tamar Way.

Holsworthy has a fascinating custom: the Pretty Maid, dating from 1841 when bachelor rector Thomas Meyrick bequeathed a 'portion' each year to a young single woman under 30, 'quiet, esteemed and noted for her attendance at church'. Pretty Maids are still chosen in secrecy and presented on the steps of SS Peter & Paul's church at the opening in July of Holsworthy Fair.

HONITON

Was Devon unusually prolific in leper hospitals? Nobody's been able to answer this question but it seems strange that evidence of at least four came to light whilst I trotted around the county. Unlike Taddiport at Great Torrington the chapel at Honiton no longer serves a religious purpose. Having been until recently used by the Assemblies of God it's now a private dwelling which can be seen from nearby Beggars Lane.

St Margaret's Hospital almshouses are also now private homes. They straddle the Exeter road, easily distinguished by their thatch and Gothic windows. The hospital itself is mentioned in 1374 documents, later rebuilt by Thomas Chard, the last Abbot of Forde Abbey, in around 1530 as almshouses for the poor. What makes St Margaret's especially interesting is its association with a local fable of barren women.

Honetona was a Domesday manor near the re-routing of the old Roman Fosse Way, reputed to have occurred in AD 50. This famous market and coaching town on which a huge lace industry centred from around the 17th century – and where serge and potteries also brought wealth – has more versions of the source of its name than most. 'Honi' comes from bees, swarming in the nearby valley; 'honi' is derived from whetstone pits near the old settlement. Could 'Huna' have been an ancient villein who first lived here, is it from 'hen' – 'old' in Celtic – or does the name come from 'honi' meaning shame or disgrace?

The last has echoes on the town's seal, presented to the borough of Honiton in 1640 by Sir W. John Pole. It appears to

show a pregnant woman, kneeling to an idol, pictured only from the waist up. Above them is an 'obstetric' hand with its first two fingers extended and a flower. The obstetric hand may be a relic of ancient Roman ideas; a closed hand with two fingers extended warded off the evil eye.

Legend says it was commonplace for ladies who were barren to visit the chapel of St Margaret and spend a day and night praying to the saint for a miracle. St Margaret of Antioch is the patron saint of pregnant women. Alas for the legend; today Huna's Farm is believed to be the true origin of Honiton's name.

IDDESLEIGH

——— Perhaps Iddesleigh is not the village to visit if you hate narrow Devon lanes with passing places and travelling between Devon banks. (For the uninitiated, these are high banks with foliage piled on the tops which often contain hidden stonework.) Otherwise, a pleasant drive through undulating countryside from the B3217, reached via Sampford Courtenay or from the A3124 south of Beaford, passes the aptly named hamlet of Bullhead bringing you to Iddesleigh. It perches on a slight rise and is part of Mid and North Devon's Tarka Trail.

There's a sloping triangular village green, facing south, with a flagpole commemorating George V's coronation and lots of cob and thatch cottages to enjoy, interspersed with stone and slate houses. Michael Morpurgo, the children's author who brought Devon to the attention of most of England in 2001 with his moving book *Out of the Ashes*, lives here and enables city children to experience country life at first hand.

Just down the lane towards Monkokehampton – a bigger but less beautiful village – is Ash House, where an endangered breeds centre was the family home of the Mallets until 1875. There was once an Earl of Iddesleigh: Sir Stafford Northcote, Foreign Secretary and a privy councillor in the 19th century. He didn't live here – unlike Jack Russell of the terrier breed fame who was curate from 1830–1836 – but owned 2,000 acres of the parish.

So why visit this 'back-of-beyond' with only one pub and precious little else? Stand to the left of St James' church door and face south for the answer. The views are stupendous; a veritable panorama of Dartmoor, with High Willhays perhaps the highspot

(literally). St James' is a 15th century building restored in 1848. Inside, if you can tear yourself away from the view and find Mrs Ellis at Old Northcote Arms for a key, is what is believed to be a Green Man on one of the window bases in its south wall. Memorials to families at Ash House and a cross-legged effigy of a knight c1250, half-hidden behind the organ, are among several intriguing items on view. You'll probably enjoy a chat with Mrs Ellis, who has had an interesting life and is quite an expert on antiques. Choose the right spot to converse like I did and that ever-changing panorama can only add to the pleasure.

ILFRACOMBE

—— Ever wondered what a typical Victorian seaside place looked like? Here's one. This former North Devon market town and fishing port grew rapidly beneath the seven ridges of the Torrs between 1861 and 1891 after an initial burst in the 1830s. It's full of Victorian architecture, especially terraces in which people like Beatrix Potter once stayed for the summer. This is where some Lundy Island boats leave from (others go from Bideford); restored steamers run Bristol Channel trips, reinforcing Victorian or Edwardian images.

Sea bathing with machine provided took place from the late 18th century at Wildersmouth and Outer Harbour, by the 19th century also at Rapparee Cove. Care of bathing huts here gave rise to the 'man who fought the Kaiser'. In 1878 Alfred Price, son of the beach huts' owner, had to defend his father's property from a stone-throwing Prince Frederick William of Prussia (aged not two years but almost twenty!). An ensuing fight was broken up by the Prince's entourage and Alfred gained a nickname for life.

To cater for the practice of taking the waters Ilfracombe Bathing Company provided indoor baths with a Greek revival style building (now a private residence) in Bath Road, adjoining Tunnels Beaches. These beaches were cut into the rock in 1836, creating silver shillet areas (a cross between sand and shingle) on either side of a rocky projection. Segregation of the sexes was thereby assured until 1905 when mixed bathing was finally allowed. A man was employed to sit on the rocks and blow a bugle if anyone tried to creep round for a peep.

Nineteenth century illustrations show machines and bathing women in attendance – something you won't find today. They also confirm that a wall along the rocks, creating a pool less at the whim of tides was not built until later. The novelty of paying to go through an old turnstile in the tunnels onto a sheltered tidal beach can still be enjoyed.

My children complained in the 1970s about a lack of ice creams etc here. Looking down onto Tunnels from near Torrs Walk outside the Granville Hotel, it looks as if this has now been remedied. What would Victorian visitors have made of such commercialism?

ILSINGTON

Ilsington owes much of its history to the stones of Dartmoor and to mining, being on the route of Haytor's former granite railway, or tramway, to George Templer's canal around Teigngrace.

Below the village, itself built into a steep slope below Haytor Vale whose cottages housed quarry workers, was the Lenda silver mine, worked until around 1870. Now a place of thatch and slate roofs, blending with some modern barn conversions, Ilsington has a lengthy past. Some of this can be seen in St Michael's Cottages – formerly the church house.

Arched granite doorways and pillars, a huge restored lateral chimney stack and old window lintels in cottages one to three have been carefully preserved over the centuries. In Henry VII's reign the church house was Ilsington's parish poorhouse, being later sold into private ownership in 1839. The most recent restoration took place in 1938, courtesy of Captain C. H. Quelch.

Next door to St Michael's Cottages, with an entrance beneath leading via the west lychgate into St Michael's churchyard, is the former village schoolroom, certainly in use for the purpose in 1639 when an accident was recorded. A village woman passing beneath left the heavy gate to close itself which, with the force of the wind, took place so firmly that the building above collapsed. Miraculously none of the 15 children in the school was killed; a school register entry says injuries were slight.

The rebuilt schoolroom and archway under which the current lychgate is a 1908 replacement have proved a focal point for

Ilsington memorials. The statue of St George facing the village commemorates men of Ilsington named on an adjacent plaque who died in the First World War. Restoration to an extension to the churchyard remembers losses in the later world conflict; Queen Elizabeth II's Silver Jubilee in 1977 was marked by restoring the old schoolroom and its outside steps (typical of Dartmoor's old church houses).

INSTOW

We're on the line to nowhere here! As you enter Instow from the A39 road linking Devon to North Cornwall, it's quite spooky to arrive at level crossing gates and signal box, not to mention a platform – where the lines peter out – with trunks and milk churns awaiting a train that will never arrive.

The 1861 signal box is a Grade II listed building filled with railway memorabilia including the station clock. The London & South Western Railway reached Instow in 1855, bringing tourists and buildings to a tiny hamlet. The signalman exchanged tokens here to clear a single-line operation; clay was carried to Fremington after arriving by boat.

A plaque on Instow's railway platform commemorates the South West Peninsula Coast Path's completion in 1987; the path and cycle track continue behind the right-hand level crossing gate and re-emerge near Instow's cricket club – of which more later. From Easter to October the signal box, last of its kind in South West England, is opened on Sundays, Tuesdays and bank

Thatched cricket scoreboard at North Devon Cricket Club.

holidays for viewing. Across the old trackbed buildings once part of the station now serve North Devon Yacht Club.

A stroll along Instow Quay, where seasonal ferries run across the estuary to Appledore, leads past a varied parade of shops. The Commodore Hotel (recommended for a snack lunch) stands back behind the road, protective wall and sand dunes. Beach car parking facilities are at the head of a double lane, leading to the water – and to North Devon Cricket Club, founded in 1823, making it one of Devon's oldest.

A walk or drive down the lanes is a must, to view the club's thatched pavilion and clubhouse. The pitch runs towards the water's edge; to the left of the pavilion stands its pièce de resistance: a thatched cricket scoreboard. It has been built on a small hump. Is there another such in the county? If so, I wonder whether it can boast estuary views to equal those at Instow.

IVYBRIDGE

Almost every postage stamp in Great Britain was once printed on Ivybridge paper. The mills are still here at Stowford, owned by Arjo Wiggins, turning out fine papers in the 1862 buildings. The first Stowford Mill was built by William Dunsterville, a Plymouth miller, in 1787; Ivybridge existed by milling: corn, cloth, tin, edge tools and finally paper.

Ivybridge or Ponte Ederoso – named for Alfred de Ponte Hedera (who received a grant of land in Edward I's reign) – once centred on its early 13th century packhorse bridge which crosses the river Erme near Stowford Mill. J. M. W. Turner painted the Ivy Bridge – there's still ivy growing on it; it marked the junction of the parishes of Cornwood, Harford, Ermington and Ugborough and stood in front of the London Hotel, which has been converted into sheltered housing apartments. Each June parishioners of Ermington challenge Ivybridge residents at the bridge, demanding crossing tolls which include a roll of Stowford Mill paper.

Cross the famous bridge, which serves one-way traffic, into Station Road and follow the Erme through Ivybridge's community woodland as it noisily splashes towards Sir James Inglis's stone railway viaduct. In 1848 Isambard Kingdom Brunel designed an eight-arch timber viaduct here with granite piers to

carry his Plymouth line high above the river. The old piers can be seen between the new arches of its 1893 stone replacement.

A two hour walk centred on the Erme passes St Ann's Pool, where the ghost of Stowford Manor's one-time lord Tom Treneman (sometimes Trinniman), unable to rest, is fabled to have been given the task of emptying water with a holed vessel. When the river is in spate, can we really hear him crying?

Today's Ivybridge has been hugely extended to become a suburb or dormitory town for Plymouth. Its shopping street is part-pedestrianised; the railway at Ivybridge has similarly become a Parkway – something Brunel could never have predicted. At this specially constructed station the area's commuters park their vehicles and travel by train into Plymouth. It is part of Devon's anachronistic charm that beside Stowford House, within a short distance in the direction of Harford, the Two Moors Way leads walkers onto Harford and Ugborough Moors and to the wilds of Dartmoor.

KINGSBRIDGE

From Squeezebelly to Leighamiter, Kingsbridge – 'gateway to the South Hams' – is a place of passages. Behind Fore Street, climbing from the head of Kingsbridge creek by the Quay to beyond the Cookworthy Museum of Rural Life in the town's 1670 former grammar school, run two Backways.

It's easy to imagine the main street, with buildings of importance – shambles, market house, coaching inns, town hall and church – would have been crowded even before the advent of motor traffic. Nipping up the Western or Eastern Backway and in or out of Fore Street via one of many narrow passages must have been easier. It can have advantages today.

Mill Street, where the original Abbot of Buckfast's corn mill became a 19th century cloth mill, leads into Squeezebelly Lane next to the Hermitage, and thence into Western Backway. Here the mill's backleat or backlet still runs downhill, bridged by slabs of slate – probably from nearby Charleton village. It tunnels under walls on the climb to Baptist Lane where Phoenix Place has 'listed' houses; entry into Fore Street is through a short passageway. White Hart Passage and Place recall the recently closed inn, now selling beds instead of

renting them out by the night. Wooden beams in the Passage look very ancient.

Eastern Backway begins in Duncombe Street with the former Cottage Hospital; another dried-up leat bed is filled with greenery. This backway takes several right-angled bends in its path downhill. Passages into Fore Street from this side include Kings Arms Passage (there were lots of inns) and Leighamiter, very tall and narrow, housing a Quaker meeting house.

The town's main church of St Edmund, King & Martyr is among the many old buildings of Fore Street. Beside its small chancel door is a famous memorial which speaks volumes about attitudes in 1793:

> 'Here lie I at the chancel door,
> Here lie I because I'm poor;
> The farther in, the more you'll pay,
> Here I lie as warm as they.'

Robert 'Bone' Phillip, described as cooper, herbalist and whipping boy, at whose request these lines were included, would have felt even more justified in his social comments could he have foreseen how town worthies would treat workhouse occupants in around 1850. When they erected the town hall and topped it with a clock on the ornate tower it was given only three faces. The blank one faced the workhouse, to prevent inmates from seeing the time while working.

LAMERTON

'A grazing place for lambs beside a river' is how Domesday described Lamerton. The area survived through mining in the 18th and 19th centuries. Everything here seems tiny; even the church is up a small cul de sac. Collacombe Manor, a Saxon estate which was home to the Tremayne family from the 14th century, was well tucked away to preserve privacy. It 'bucked the Lamerton trend' in having a massive transomed window in the hall with over 3,000 panes of glass.

Once you discover the churchyard gate, a hidden treasure reveals itself in the shape of a 13th century priest's house. Admittedly it was restored in 1934, but old material was

painstakingly used.The near round-headed doorway is of granite. Ground floor windows are minute, as might be expected. What rewards the eye is a sign on the door within St Peter's churchyard: 'The Chapel'. This is an old building still serving a useful purpose to the parish today.

It might also have been invaluable when the church burned down in 1877, leaving only the tower, and had to be rebuilt in its 15th century style. How did the fire start? By a draught from a broken window causing an oil lamp – kept alight to stop the organ becoming damp, making its keys stick – to flare. A few missed notes might have proved less expensive.

LEW TRENCHARD

Visit Lew Trenchard (recently often written as one word) and you're close to Uncle Tom Cobley and Co without knowing it. Lew is the parish of the Reverend Sabine Baring-Gould, who was its rector for 43 years. Novelist, antiquary and musician, Baring-Gould collected a volume of old folk songs of Devon with Cecil Sharp. Among the treasures was *Widecombe Fair*.

An entire Baring-Gould trail centres on Lew Trenchard taking in Lew House – now a country hotel and restaurant whose gardens are sometimes open under a national scheme. When the simple rectangular manor house purchased from Thomas Monk by Henry Gould in 1626 eventually passed to Sabine Baring-Gould (the name was hyphenated from 1795) he was largely responsible for its transformation into an E-shaped Jacobean residence. No architect was employed; the family trained local craftsmen for the construction. Stone was quarried from land north of the house.

The Baring-Goulds were inveterate and energetic tinkerers. Sabine's grandfather broke up St Peter's church rood screen in 1833, part of preparations for making the building 'spick and span for my Uncle Charles'. Sabine, later to be Squarson – a mixture of squire and parson – collected fragments aged 15, hid them and later decided to reconstruct it, advised by a cousin, Bligh Bond. It was largely the work of the misses Pinwell: 'from down Plymouth way', a man with his tractor outside St Peter's told me; paintings on the screen's central area were restored by Margaret Rowe (née Baring-Gould).

During his long and busy life, Squarson B-G found time to meet and marry Grace, a young mill girl, and to father 15 children. Their romance is thought to have inspired George Bernard Shaw to write *Pygmalion*, better known as the musical *My Fair Lady*. Sabine's time in Yorkshire, where he met Grace, was also marked by writing *Onward Christian Soldiers*.

A standing stone by the mill, further along the lane from Lew House, has the hand of Sabine in its presence. His grandfather had it thrown down to prevent farmers using it for what he regarded as superstition. It was customary to encourage cows to rub against the stone while splashing them with water from inside its hollow top to increase milk yields. Baring-Gould had it re-erected.

The village proper is Lewdown, on the old A30 to Okehampton, with shop, petrol station, post office and inns. If you're a Jethro fan, look no further – this is his home territory too.

LODDISWELL

——— Loddiswell is a large village on the slopes above the river Avon or Aune which, not surprisingly, once had three grist and fulling mills. It was a place of wool combers, weavers and serge makers; today its inhabitants work mainly in Kingsbridge or Plymouth.

Blackdown Camp, known as The Rings – an Iron Age hill fort and castle (probably Norman) – is north of the village; nearby, in its own hamlet, is Hazelwood House which hosts concerts, courses and weddings.

Richard Peek remodelled the house in the 1830s, when it was thatched. 'Little Dick Whittington', as he has been nicknamed, left Loddiswell and walked to London, working in tea warehouses to learn the business, before fetching two brothers from Devon to help him set up on his own account. Thanks partly to the collapse of the East India Company's monopoly the family made a fortune on the premise of 'good quality tea, cheaper than rivals – provided accounts are settled within a month'.

The Peek family, also connected with Combpyne and Rousdon in East Devon, were nothing if not philanthropic. Loddiswell benefited enormously from Richard's good fortune – in addition to the employment created at Hazelwood, where estate cottages,

a chapel with family catacomb below and a riverside boathouse took shape.

Within Loddiswell itself Richard endowed a Congregational chapel in 1864, easily recognised by its twin towers with conical caps. One side is slate-faced, the rest substantial stonework. Next door is the village school, also paid for by Richard Peek – now much obscured by an added verandah-style terrapin and modern forward entrance extension. In 1832 he attained – not quite equalling the first Dick Whittington – the position of Sheriff of London.

I'd love to say that Loddiswell is a beautiful village; it isn't. It's lively, busy (especially when school finishes), has an inn noted for good food and a central grassed area near St Michael & All Angels' church – which has to be kept locked. Visit Loddiswell for its setting, especially down by the Avon, and to admire Richard Peek's philanthropy. Then leave its one-way system and head for Blackdown Rings, and perhaps detour for a peek – at Peek's former home at Hazelwood.

LUSTLEIGH

—— Thrones in Devon aren't too common, but they've got one at Lustleigh, a village off the A382 between Moretonhampstead and Bovey Tracey, within Dartmoor National Park. It's not difficult to understand why villagers here used sledges in the steep lanes for transport – in all weathers.

The village and Cleave are noted for their scenic beauty; Lustleigh's centre shows the influences of tourism with a large thatched restaurant and tea gardens close to the 15th century Cleave Inn and, surprisingly, a gospel hall with corrugated roof in the valley below the church of St John the Baptist.

Once a year visitors from miles away come to Town Orchard to celebrate a relatively modern adaptation of an ancient rite. The Orchard, through which Wrey Brook runs, is part trees, part play area given to the Parish Council in 1966. A stroll between grassy banks and rocky outcrops brings you to the huge May Day Rock on which is a man-made throne. Here, on the first Saturday in May, a young village girl of twelve years or more who has danced 'the maypole' more often then her peers, is crowned as Lustleigh's May Queen under a bower of flowers and greenery.

May Queen's rock and Millennium throne, Town Orchard.

Cecil Torr is credited with creating Lustleigh's special day in 1905. Initially the queen was enthroned on a rock at nearby Luxtorwrey following a short service and a procession, with many halts to sing May songs. When Bill Bennett and others revived the event in 1954 coronations moved to Town Orchard.

Gillian Williams was May Queen in that year; her name is carved on the giant rock. Her throne was far less carved and geometric than the new one – produced to celebrate the recent millennium to a design by village architect Doug Cooper. Local siblings – or cousins – appear among names in various decades. The honour of leading the parade from Lustleigh village hall clad in white with a posy of spring flowers, before returning to a blessing on St John's steps and presentation of a silver and coral necklace, is still much sought.

Can we trace the ceremony back to the festival of Flora, Roman goddess of flowers? Not in Lustleigh itself perhaps, but Dartmoor is full of Beltane traditions from Celtic times of burning cartwheels and cattle driven through flames in the cause of fertility.

 LYDFORD

'I oft have heard of Lydford Law,
 How in the morn they hang and draw,
 And sit in judgement after'
 (William Browne, 1644).

Close to Lydford village is a well-visited National Trust acquisition, whose stark natural beauty includes White Lady waterfall and Devil's Cauldron, along a one and a half mile stretch of the river Lyd. Small wonder it has legends, including the one about the white horse that leaped it on a wild winter's night while carrying a desperate traveller between Plymouth and Okehampton. The Castle Inn – long and pink-washed – was previously named in the animal's honour.

Some of the coins minted in King Alfred's 'burh' can still be seen here. Lydford was a Domesday borough and later the centre for administering Dartmoor's Royal Forest. When tin made the area metal-rich, Lydford was chosen to dispense justice for the stanneries by King Edward I.

People who visit Lydford Gorge sometimes don't get as far as Lydford Castle, although the hump is clearly visible in its village centre. Used as a dungeon for those who broke the harsh Forest laws, it was built around 1195 less for protection than to act as a courtroom and hold those awaiting verdicts. Due to a complicated system of courts – Attachment, Swainmote and Justice Seat – an offender might languish there indefinitely. Hence many verdicts were anticipated, as William Browne's rhyme illustrates.

Conditions would have been dire; in the 13th century a ditch was dug around the castle during rebuilding and the soil removed was packed around the ground floor. The two storeys visible today were supported by a third below ground, housing the dungeons.

Member of Parliament Richard Strode of Plympton found himself in one in 1512 when he attempted to convince Lydford's tinners that they were not above the law regarding silting up harbours with sand from their workings. Only an appeal to the King eventually freed him. As a result he later carried through parliament the bill giving MPs the right to freedom of speech without arrest.

Punishments for tinners were often barbaric; those who debased their metal before it came for assaying would have some of the spoiled molten ore poured down their throats.

LYNMOUTH AND LYNTON

——— Lynmouth has the doubtful distinction of having been largely rebuilt, unlike most Devon seaside resorts. Events of 15th-16th August 1952 destroyed much of its history, along with some inhabitants, when the Lyn poured through its centre.

Today only the newness of some properties and the excellent model of how Lynmouth looked before that fateful night, housed in the Flood Memorial Hall, give clues to the changes in this former herring fishing port, and tourist attraction of the 19th century. On the pier stands Lynmouth's Rhenish Tower: not the original, which stood in the water's path in 1952, but a faithful reconstruction. General Rawson had it built in the late 1850s in the German style, to store salt water for baths in his house. By 1860 he had decided to add battlements, whose design he reputedly chose from a painting in his friend's house.

This imitation tower sat well with comparisons made between Lynton and Lynmouth, with their two Lyn gorges, and areas of the Rhine and Black Forest. Conifers in the woods echo the German flavour; opening a Zahnradbahn – the longest cliff railway in Britain – in 1890 from the port to the small town above only extended comparisons.

By 1905 the Rhenish Tower, with its beacon basket on top, castellated in brick with stone below, had found a more prosaic use. With the addition of an electric beam in the tower, it guided ships into Lynmouth's harbour.

What would Percy Bysshe Shelley have made of Rawson's flight of fancy? He used the cottage on the site of today's Shelley Hotel at the foot of Glen Lyn Gorge for two months in 1812, when fleeing with his 16 year old bride Harriet from her irate parents. Shelley himself was aged a mere 19 and had been rusticated from Oxford University for his atheist views.

Shelley wrote *Queen Mab* here before the irresistible urge to convert North Devonians to his views drew attention to his presence. The couple fled by boat in the nick of time. His cottage burned down in 1907, was built as a hotel and named for the poet – only to endure more renovations after 1952.

MAMHEAD

On the hill above Mamhead House, almost hidden in woodland among forest walks, is Thomas Ball's Obelisk (OS grid reference 925806). Mamhead was the house which established Anthony Salvin as one of the greatest architects of his time for work in the Tudor style; it was built around 1830 when Salvin was only 26. A battlemented fort in Bath stone was made even grander by stables and a laundry in red sandstone, further up the hill, with a portcullised gateway rather like a castle.

He was building for Robert William Newman of the famous family of Dartmouth merchants whose descendant Robert Hunt Newman, Lord Mamhead, was MP for Exeter, replacing a nearby property of the same name in which Thomas Ball(e), another 16th–17th century merchant, and his family had lived. Thomas and Peter Ball collected rare trees during travels to enhance the old house, whose parklands received attention from no less than Capability Brown.

Ball's Obelisk, which overlooked the river Exe close to its estuary, was intended as a daymark: 'out of regard for the safety of such as might sail out of the port of Exon, or any others who might be driven on the coast'. You can find the single pillar of stone by following blue marker posts from Mamhead Forest Walks car park, just off the A380 at the top of Haldon Hill. Admire the weathervane at its summit; perhaps admire is not the right way to suggest you also notice the mass of 19th and 20th century names and initials carved in its lower regions.

An alternative story behind the building of Mamhead Obelisk is rather sad; the chief reason for raising it may have been to remind people of the Ball family, whose line was due to end with its creator. In any event, we should be grateful to him. A viewpoint constructed nearby affords stupendous views: north upriver to Topsham and Exeter Canal, east through Exmouth towards Straight Point and more distantly to Peak Hill and Beer Head, south and west down the coastal strip to open sea, across the hills beyond Exeter and into Dorset.

MANATON

From Bovey Tracey the road to Manaton via Becka (now Becky) Falls crosses Trendlebere Down; views across Lustleigh

Cleave and the Bovey valley alone make the journey worthwhile.

Manaton's a village in two parts. In the new are shop, post office and the Kestor Inn; half a mile away lies the church, village green and 'big house' – Manaton Gate – in the former Manaton Magna. There was once a primary school here, a second inn and a separate post office.

The church is dedicated to St Winifred; it's one of those in the county (see also Ashton) with an interesting rood screen whose religious figures were defaced by gouging in Edward VI's reign, on Cranmer's orders. Easily missed among the old stones in St Winifred's churchyard is an interesting piece of ecclesiastical history – and superstition. Just inside its west gate stands an old granite cross; these often marked the spot where early friars gathered their congregations together. When burials took place, the coffin was first carried three times around this cross, in the direction of the sun's journey, before taking it into church, or carrying it to the designated resting place.

People believed that this action confused the spirit of the dead person so he – or she – couldn't return to haunt the living. The nearer to a cross you were buried, the sooner your soul would be released. As not every grave could be near the stone, it was advisable to take the corpse there first instead.

A rector in 1841 disapproved of such superstition and had the cross removed from its base. Until 1908 it languished as the base of a stile near a stream – or so it was supposed. In that year St Winifred's incumbent rescued it and replaced the cross in its socket-stone. Somewhere in the intervening 40 or so years something had changed. The cross didn't fit into the base properly, it was discovered. Where did the real one go – and where did this one start its life? Thus are reputations tarnished; villagers never felt the same once the mistake came to light and another Devon custom died out.

MEAVY

The Royal Oak Inn at Meavy is unusual in remaining in parish ownership long after most church inns or houses; it is also a village information point. Meavy has not had a post office for about 20 years, but there's a village hall opposite the green with

a useful car park. Apart from a replica of Drake's Drum (the original is at Buckland Abbey) as you enter the village, and St Peter's church, why visit Meavy?

On the green are two oaks, one obviously younger by some centuries than its neighbour. The senior citizen is the latest Gospel Oak; the earliest of these was mentioned as being at 'Mewi' in the Domesday Book, although legend claims it was sown around 1122 when St Peter's was founded. Today's Meavy Oak is over 500 years old and has to be supported by artificial means. Maids (as we call them in Devon) from the village traditionally played skittles round it on Trinity Sunday; the winner received a gown and bonnet. Teas were provided before dancing and something stronger ensued: grog or beer for the lads and citrus juice, rum and sugar for the girls.

Sam Gaskett had cause to bless the Meavy Oak according to a well-established story. The tin miner and his wife were almost down to their last penny when Sam went to collect a few fire turves, which he stacked in the oak's hollow trunk. Among them he found a purse containing several guineas. Sam searched for its owner before deciding to put the money away safely.

It seemed to change his luck; a new position at the mine was offered on condition he had some schooling. Then a stranger called asking directions. Was this Meavy? He remembered passing through it when he lost his money. Sam's offer to reunite the man with the purse was turned down when he recalled he had found it 'before I went to school'. 'Not mine then,' said the man, and left.

I mentioned two oaks. The second, commemorating those who fell in two World Wars, awaits its time for promotion. Judging by the fungi and evidence of beetle attack in the old Meavy Oak, that day may not be too far hence.

MERTON

Who would expect to find a top national collection of barometers in a mid-Devon village barn? Retired bank manager Edwin Banfield started acquiring his weather collection in 1971 and has since become an internationally renowned author on the subject of all types of barometers.

Some eight years later Philip Collins, who had recently moved to Devon and who was interested in antiques, especially

instruments, met the Banfield family and their collection. The result is Barometer World and Museum in the aptly named Quicksilver Barn, where an exhaustive history dating from 1680 can be unravelled. There was Admiral Fitzroy (of HMS *Beagle*) and his coastal storm barometer for example. His invention led to the first meteorological forecasts and was adapted for domestic use.

Philip Collins' research produced other ancient methods of forecasting – like Dr Merryweather's Tempest Prognosticator, exhibited at the 1851 Great Exhibition. It involves leeches, bottles, wires and bells … but if you visit Merton you will find that Philip has created a demonstration model, so I won't spoil the fun.

Barometer World also stocks old, new and replica barometers. Their workshop (not open to visitors, although I begged a peep) restores and creates all types including barographs and Collins Patent table barometers. Everything takes place in the hands of their skilled craftsmen except engraving. There's a glass blowing section and even a small kiln outside which is fired occasionally.

Don't be surprised to find yourself rubbing shoulders at Merton with the likes of Michael Fish, or an international barometer enthusiast. Philip Collins himself is now considered an authority on barometers so many people seek him out: 'second best known to Edwin Banfield'.

Walter de Merton, founder of the Oxford college of the same name, would have approved of this late 20th century addition to his birthplace, as might General Monk of nearby Great Potheridge – far-sighted enough to 'broker' the Restoration after England was torn apart by civil war. Barometer World has certainly put this largely agricultural and rather quiet village astride the A386 firmly back on the map – or should that be 'weather chart'?

MILTON ABBOT

──── There is more than one type of 'model village', as I discovered at Milton Abbot. This is life sized, designed by Sir Edward Lutyens in 1909 for the Duke of Bedford, whose family retreat had been built nearby at Endsleigh almost a century earlier.

Lutyens created areas of gabled houses whose overall impression is of grey and white, around St Catherine & St Aegidius' church. There's a particularly good terrace on Venn Hill. Most 19th and early 20th century buildings in Milton Abbot can be attributed to the Russell family, who owned much of Tavistock following its abbey's dissolution. The vicarage is a Tudor-style mansion, attributed to Blore in 1837; two further groups of houses west of the church were designed by Cannon, architect to the Bedford Estates. Even the Bedford farms in the parish, at Leigh Barton and Beara had planned or 'model' layouts.

Along the B3362 (the former A384) towards Milton Green is the old school, designed by Wyatville, who also designed Endsleigh Cottage as the Bedfords' country seat. With shell grotto, thatched Swiss cottage, summerhouse (where you can stay nowadays thanks to the Landmark Trust) and daisy dell in the grounds laid out by Repton above the river Tamar, Endsleigh resembles a series of cottages rather than one. Georgiana, wife of the sixth Duke who lavished this retreat on her in 1810, must have been delighted by it.

From a spell as a hotel run by a fishing syndicate, Endsleigh – signposted from the main road towards Tavistock and with a garden centre adjoining – has become a charitable trust. The house is open by appointment; the grounds open daily between April and September. A heritage grant has enabled the restoration of treasures like the shell grotto; an education officer helps unite the history and natural pleasures once enjoyed only by the Russell family for a wider public.

MODBURY

I'm not sure I'd want to be remembered by a conduit, although supplying a town with fresh water is very laudable. Adrian Swete is, however, in the South Hams town of Modbury.

From Henry VIII's reign the Swete family lived at Traine, above the settlement built in a dip which now straddles the busy A379 – and became town benefactors. In 1684 John Swete gave land at the top of Galpin Street for almshouses. Their house at the summit of Brownston Hill moved from the right to the left of the street when, in 1780, New Traine was built with its elegant

Adrian Swete's conduit.

pillars (the balcony is a Victorian addition). Above swings a massive weathervane; paddock, gardens and stables lay beyond.

The site of Old Traine, Adrian Swete's house, hides behind a cobbled pathway and arch just above his conduit, which was in the middle of Brownston Street – until the family discovered that their view from the new house was obstructed. Now it is almost embedded in the wall, with railings on each side.

The conduit is impressive in moorland granite: square and solid. Four balls mark the roof corners; a large one adorns the central pinnacle. 'Dono Adrian Swete, Equitis de Train. An Dom 1708' says its plaque, and 'in hunc sicum e media via translat 1874' (referring to the later move). Ivy tries its best to encroach; the remains of a tap and drainage grating and an unglazed window on one side can still be seen. Two other conduits – in

Church Street and Galpin Street – were the work of Lord of the Manor, Nicholas Trist – also in 1708.

Those who enjoy old diarists' work will be anxious to know that the John Swete who had New Traine built was the same man whose 17 diaries of his *Travels in Georgian Devon* between 1789 and 1800 came into the hands of Devon Record Office. They have recently been published in limited editions. He was born John Tripe in Ashburton around 1752. After being Oxford educated and taking Holy Orders he took the name of John Tripe Swete in order to inherit from a relative in 1780. As Prebendary of the Diocese of Exeter, this Swete's main home was at Oxton House near Kenton.

MOLLAND

'Warning: pheasants on road', said the sign. Too late for us, we'd already pursued two petrified youngsters for about 400 yards in second gear. You approach Molland, just south of Exmoor, along the side of a valley. First impressions are of rolling hills, fields of crops and an immense amount of sky.

The village smells very agricultural; it has St Mary's church, the London Inn, a post office and stores and a village hall on which is a ceramic plaque from the *North Devon Alphabet of Parishes*: 'R is for Red Devons'. Are they still here after all the tribulations of 2001?

At Great Champson, one of the 16th century houses on the western edge of Molland, the Quartly family began farming in the 18th century, becoming one of the first serious breeders of North Devon's famous Red Ruby or Red Devon cattle. Francis Quartly and a brother who lived nearby at West Molland Barton – an old Courtenay manor house – were especially successful. By Francis' death in 1856 this family, descended from Huguenot refugees (probably originally called Cartelois), were synonymous with Red Devon breeding. They are also credited with starting the Devon Herd Book at Great Champson.

Descendants of Francis continued the Champson herd for several generations and were village benefactors. James Quartly of West Molland gave St Mary's its organ in 1877. Memorials in the wonderfully unrestored church include one to Ronald Francis Quartly (1917–1975) – and another to a former clergyman of Knowstone who was deprived of his living there during

Cromwell's Commonwealth and sought shelter at Molland, where he died.

Today the Molland estate encompasses most of the farming in the area and, yes, there are still Red Devon – or Devon Ruby – cattle on the slopes above the village. There are no longer Quartlys at Great Champson though, according to a model of the village made by children of the parish, displayed in the family area of St Mary's church.

Look out for old stocks in its porch; I expect that's where we'd have finished up in times past for poaching a few of those suicide-bent pheasants.

MORETONHAMPSTEAD

It's easy to see why Moretonhampstead's tourist guide calls it 'Gateway to the High Moor' when you watch traffic negotiating the old coaching roads and winding leafy lanes that meet in its narrow centre. Would it attract even more visitors here if they called it 'Town of the Dancing Tree'?

Outside the gate to St Andrew's churchyard on Cross Street stands the latest: a copper beech dating from 1912. A previous elm tree was over 200 years old when wrecked in 1891. Called variously punch bowl, cross tree or dancing tree, the last name comes from a platform once placed in the (punch) bole after pollarding. In an 1801 diary it is described as 'floored and seated around with a platform, railed on one side' with 'space for 20 to sit round and six couples to dance, plus musicians.' French officers among Princetown's Napoleonic War prisoners gave an impromptu concert there in 1807.

Why cross tree? A carved depression under the stone platform where the tree stands almost certainly contained a crucifix. An old cross-head is displayed where the copper beech emerges from its stone base.

While you're in Cross Street, don't miss the 1637 colonnaded almshouses, now National Trust holiday properties and heavily photographed. A trail to some less well-known architecture with an interesting story begins where Fore Street meets the Square at Moretonhampstead's library, opened courtesy of Thomas Benjamin Bowring in 1902. Divert down Lime Street past a roadside wheelwright's 'form' to find the Bowring houses at

Kinsman's Dale. There are 25, dated 1895 and with 'T.B.B.' on their brick fronts. The evocative 'Kinsman's Dale' honours Bowring's wife's maiden name.

Thomas was a grandson of Exeter watchmaker Benjamin Bowring who emigrated from the area to Newfoundland, with ancestors who had wool connections here. All his donations were unostentatious, so they say, including prizes for local horticultural events and books for the library – which had a technical classroom on its first floor, later let for billiards and as a ladies' club by the parish council before it was taken over by Devon County Council in 1962. Bowring Mead in Moretonhampstead also honours Sir Thomas – 'dubbed' in 1913 – in recognition of a man whose life spanned the Atlantic but who retained his British roots.

MORTEHOE

Death on the Morte Stone sounds like an Agatha Christie novel, but as far as I know this wasn't part of 'Agatha's' Devon. Murt in dialect means a stumpy person and hoe is a headland; put the two together and you have somewhere where death has been only too common among mariners. Examine the jagged reefs and stacks of the Morte slates off the Point and imagine what they could do to a ship's timbers. They run out to Morte Stone itself, on which at least five ships were wrecked in the winter of 1852.

Mortehoe is a coastal village in spectacular settings on the National Trust coastline in the far north-west of Devon. The two inns include the aptly-named Ship Aground, with an anchor from SS *Collier*, a steam ship carrying mails from Australia which ran aground in 1914. It's an interesting village, with an excellent 'hands-on' heritage centre, open from Easter to October. In high season tractor and trailer rides make the journey up to Morte Point and Bull Point's lighthouse from here, encompassing some of the farmland and cliff scenery that characterise the area en route. The walk, via a path beside the church of St Mary Magdalene, is quite strenuous.

Baggy and Morte Points were especially feared by ships' masters for frequent changes of wind, and gales which blew round them from the north and west. The worst disaster here

was almost certainly in October 1859, when seven wrecks in a day littered Morte Bay. Of their crews only four survivors (in total) were recorded.

No wonder that Morte Stone was often called Dead Stone, and is also the subject of local sayings. 'He may remove Morte Stone who is master of his wife,' says one. When enough women who can rule their husbands combine, the rock will be moved, if you believe another version. It might relieve anxiety for a large number of sailors even today – as long as the ladies concerned aren't their own spouses.

NEWTON ABBOT

'Return to Newt'n' rabbut', the man at my railway station often quips. Many people know Newton Abbot from a roundabout at Penn Inn, where they begin the crawl into Torbay and never investigate the market and railway town beyond.

Markets are still very much a part of Newton's raison d'être, as they have been since there were two: at Sherbourne Newton and Newton Bushel, which combined by the 18th century.

Railways affected this bustling town rather later – in 1846 when *Antelope* borrowed from the GWR pulled the first train into Newton Abbot station. This was part of Brunel's famous atmospheric line during its early years (see Starcross) and ran on broad gauge until 1892. Area offices and locosheds were all part of the railway's heyday here; the town's position in relation to lines to Plymouth and Cornwall and to the newly emerging Torbay resorts played a large part in its success.

Much of its history, and a special hands-on experience once limited to councillors and their employees, is in the well hidden Newton Abbot & GWR Museum at the top of St Paul's Road, beside the town hall. Centrepiece of their GWR Room is a working wooden signal, lowered through the floor into a well, with enough levers and bells from Newton Abbot West signal box to satisfy any overgrown schoolboy's (or girl's) dream.

When curator Felicity Cork arrived, and the Museums & Galleries Commission registration requirements dictated a combined museum, public access to the GWR Room became possible. It has been enlivened with more information, a video presentation made by the last occupant of the box c1980 and

several ex-drivers as stewards. They give anecdotal descriptions of how things were, to add to the fun of using a signal cloth, setting off the collection of bells and dropping the huge signal's arm. Detonation levers are especially popular with parties of children.

Plans are afoot to combine railway exhibits and archives with memorabilia from local clay works in new buildings close to Tucker's Maltings visitor centre in Newton Abbot. The new attraction will continue as Newton Abbot's museum, charting the town's development and holding its significant Aller Vale Pottery collection – another facet of a market town struggling to retain its history in the face of 21st century roads and commerce.

NEWTON FERRERS

See **Noss Mayo and Newton Ferrers**.

NEWTON POPPLEFORD

Village of the pebble ford, 'Newton Pop' was once a place which needed three toll houses to facilitate passage through its busy main street, now known for a certain cream tea haven whose name sounds like a constellation in the southern hemisphere.

There is still a toll house, built in the 1750s for the Exeter Trust and billed as 'oldest in Devon' – even in the country. (I question this claim.) A lady once lived here with a donkey for company which she kept in the shed next door. It would scarcely have fitted into the house; although the building has performed various functions since its money collecting days it's pretty small.

Newton Poppleford has several restaurants, cafés and the odd inn or two. It lines the main road for some distance, with new houses and bungalows spreading out behind. As you enter from Exeter, look out for its particular example of eccentricity in the garden of a property on the right hand side called Kirtina.

Coaches have been known to pull across, causing havoc on the winding village approach, to admire Kenneth Woodley's clock-in-a-box. Not just any box – a red telephone box, to be precise.

Mr Woodley purchased the movement and dial from an old public clock from a North Devon lady because he couldn't bear to see it thrown away. Pondering how he might case the clock, and knowing that his wife had vetoed the idea of putting it in their living room, he was driving past a red telephone box and realised it was the size he needed.

The clockmaker and repairer had also been seeking a way to publicise and pinpoint his business; he had found it. Lympstone's former Gibraltar Inn, now Nutwell Lodge, supplied a box from one of three in their grounds; in 1987 clock and telephone box arrived on the Newton Poppleford scene. BT even featured a photograph in their staff magazine.

I'm not sure whether red phone boxes have a breeding season. There's another box lurking behind a garden hedge almost opposite Mr Woodley's landmark; he assures me there's no clock inside this one … yet.

Clock in a phone box by Kenneth Woodley.

NEWTON ST CYRES

This is the place to come for cheese and home-brewed beer. Newton St Cyres lies in the Creedy valley, in the 'red' lands of Devon, so it's little wonder that important families like the Northcotes or Quickes were associated with agriculture.

The Quicke family have farmed land here for over 450 years; monuments in St Cyriac & St Julitta's church (martyrs – mother and son – in Asia Minor under Diocletian) date back to 1701. Nowadays the name Quicke means cheese; an operation updated in the 1970s wins awards internationally and exports cheeses to the Far East, Australia, USA – even to France. Their farm shop on the A377 is a pleasant place to browse; you might, however, prefer to turn down the lane towards Newton St Cyres railway station and the adjacent Beer Engine Inn to add a glass of real ale.

This pub was once the Railway Inn or Hotel; in the early 1950s it was called the Iron Horse before forsaking its railway image to be renamed Barn Owl. 'The landlord had a collection of owl memorabilia,' explained current licensees Peter and Jill.

When Peter arrived in 1983 it was decided to call the pub the Beer Engine partly in recognition of the railway but also because he and colleague Ian had decided to brew in the basement. 'Also Dave (who designed the first signboard, still in the bar) fancied doing a Heath-Robinson design.'

If sampling Rail Ale, Piston Bitter or Sleeper Heavy can be resisted for long enough, seek out the Beer Engine's full mash brewery. Unlike many small or home brewers, a process of mashing and creating wort similar to that used by big brewers is used – 'but better'. Most is consumed on the premises.

'Don't forget to say that two of Mary Quicke's cheeses are always on offer with our ploughman's lunch', Jill told me. It would be hard to decide whether to have Cheddar, Red Leicester or something smoked or herb-laced – they're all delicious. I must confess I didn't indulge in Peter and Ian's beer, however, not being a beer drinker.

Worthwhile considering if you want to finish a mid-Devon country walk with a cheese and ale lunch – and it's always possible to go home by train afterwards.

NORTH BOVEY

I went to North Bovey seeking commemorative oaks, planted by the village to remember important events of the 19th and 20th century on its green. North Bovey lies close to the Moretonhampstead to Princetown road on Dartmoor, so there was also an expectation of thatch, perhaps an old cross if I was lucky.

The triangular sloping village green had all these – and more. A pump with a granite basin, an ancient cross, a mounting block for riders (celebrating Elizabeth II's Silver Jubilee) and a thatched village hall. Not all the trees have granite plaques at their feet, but Queen Victoria's Golden and Diamond Jubilees were honoured, the signing of peace with Germany (dated 1920) and several 20th century coronations and jubilees. At this rate they'll soon be running out of space!

The cross has a chequered history; it is not, local historians claim, the original, broken during the Civil War and supposedly built into the wall of the cottage parlour opposite. According to Dartmoor historian William Crossing, today's version was discovered in use as a footbridge over the nearby Bovey Brook, rescued and set up by a local curate, Rev J. Pike Jones, in 1829. Its history is doubtful, but the shape suggests a former Dartmoor waymark.

There's plenty of thatch in the village, including a row of cottages near the green, built by Viscount Hambledon (of W. H. Smith fame) who acquired North Bovey and other parishes from the Earls of Devon. The family also had the Manor House built on neo-Elizabethan lines. Now a hotel off the road to Postbridge in lovely grounds it was sold to the GWR after Hambledon's death for golfing visitors, to help pay staggering death duties.

The Ring O' Bells, off North Bovey's Square, is an ancient inn erected in 1248 and lodging masons building the church of St John the Baptist where Viscount Hambledon and other Smiths are remembered. That thatched village hall was once the stable for St John's rectory – which perhaps explains the location of the commemorative mounting block.

NORTH MOLTON

See **South Molton and North Molton**.

NORTH TAWTON

—— Perhaps this small ex-market town could be styled a place of singular 'a-spiring' towers. The Roman road passed through North Tawton; there was a contemporary fort to control its crossing over the river Taw en route to Cornwall. Alas, the fort's remains were ploughed into fields south of the old railway near the river as part of Second World War efforts. Only aerial photography gives clues to the extent of Roman military works in the area.

Once North Tawton was wool rich, had a bark stripping industry, a market house – even made ginger beer. And was the factory's owner the inventor of the glass marble self-sealing bottle, known as a codd? Opinion is divided. These days this is a small community almost living on its past, fighting to prevent its last mill being demolished for housing – and of course there are the towers.

One, in the triangular market place, is a very obvious Queen Victoria Jubilee clock tower (this time for her Golden anniversary in 1887). Built partly of stone and part in brick it has a strange four-sided stone and shingled tower-cum-spire above the clock itself and seating around the base.

Along the road lies St Peter's church, 13th century in essence, built from granite and rubble (known as ashlar), faced with crop stones from the fields. The low west tower has a shingled spire rising from it. A lone clock face on one side of the squat tower looks like an afterthought. The spire was rebuilt in 1834, somewhat shorter and of a different shape to its predecessor – due to insufficient funds being available for full restoration after a major fire.

NOSS MAYO AND NEWTON FERRERS

—— This is the South Hams district at its very best. Noss and Newton face each other across a creek of the Yealm estuary – as do their two churches: Holy Cross, Newton Ferrers and St Peter's, Noss Mayo. The villages are built into high river cliffs; plenty of yachting and other boat activity is in evidence.

A turning just before Newton's harbour enables you to drive round to Noss through Bridgend, where the creek disappears

St Peter the Poor Fisherman – redundant church at Revelstoke beach.

beneath the road bridge, among thatch and lovely names like Crumpet Corner and Pillory Hill. To find a 'hidden' treasure, pass the current church of St Peter and follow the lane to Revelstoke, signposted 'Stoke Beach', via a road directing the traveller to Holbeton. It's not far – perhaps a little over one and a half miles – before you reach a car park above Revelstoke Beach caravan site. In season it's possible to drive down; they operate a barrier system.

The valley is full of bird and squirrel activity. At the bottom follow the road to the right and there is the old church known as St Peter the Poor Fisherman. Parts have stood here for over 1,000 years although the nave – open to the sky – and chancel with side aisle (partially roofed and glazed) are basically 14th century.

Why such an isolated situation? There may have been a settlement at Revelstoke on a cliff which later eroded. Perhaps as an intended defensive stockade to repel Danes – Revelstoke in Middle English translates as 'reafull': 'disturbance' and 'stock': 'stockade'. Lastly there was probably a farm here belonging to the Revel family who were lords of the manor.

In all events, St Peter's burial ground, granted in the 15th century, relieved the need to carry bodies to Yealmpton. In 1840 the church was storm-damaged and a chapel of ease in Noss Mayo (now its village hall) was used instead. By 1869 Revelstoke's church was declared unsafe; Edward Charles Baring offered to build another in the village. Its ruins, covered in brambles, were rescued by local efforts. The Redundant Churches Fund stepped in and in 1972 major work restored it to the present condition.

Friends of St Peter the Poor Fisherman watch and work here; two services take place at Revelstoke each summer. If you go there, don't miss one interesting detail; two plaques opposite the old Ten Commandments boards commemorate Kate and Hilary Greenwood, who died in the 1970s. 'Who loved and saved this church', reads the plaque in Kate's honour. A wonderful epitaph in a situation which could hardly be bettered – except when winter gales batter the adjoining beach.

OFFWELL

As its name suggests, Offwell was Offa's Well in Saxon times. The East Devon village owes much of its religious – and other – development to the Copleston family, who held the living unbroken from 1773 well into the mid 20th century. Edward Copleston (1776–1849) was one rector there destined for higher office; in his lifetime becoming Bishop of Llandaff and Dean of St Paul's.

His heart seems to have remained in Devon, to judge by the legacy he left Offwell – and travellers on the A35 above Honiton who are puzzled by an unusual tower. Edward restored St Mary's church, built Offwell House and the rectory, a school in Tudor style and several cottages with rustic porches. The school, now a C of E controlled primary in the heart of Offwell almost opposite the church, bears the daunting slogan 'Fear of the Lord is the beginning of wisdom' over its door. Outside the fenced-off perimeter is a curious pillar, rather like an old cross, carved at the base. Most of the lettering is unreadable, but it is part of Copleston's memorial. He also had a pump placed on the site of Offa's Well in 1830 – its trough is now filled with flowers.

Bishop Copleston's tower.

What inspired Copleston to build Honiton Hill Tower – also known as Bishop Copleston's folly? The bishop jokingly said he wanted to keep an eye on his diocese in Wales, whilst not actually being obliged to live there. Nearer the truth is probably an appreciation that work was needed for the unemployed in the area around 1842, when the project began.

The tower reaches 70 feet to its viewing platform and 100 feet to its weathervane, having four floors internally. In the early 1900s a water tank was installed on the top floor of what Pevsner called 'a crazy Italianate campanile'; perhaps it does look as

though bells wouldn't be inappropriate, and they would certainly enhance its … dare I say, appeal.

For a close-up look, take the Northleigh and Farway turning at the top of Honiton Hill. Tower crossroads is a mere 200 yards (that's what the sign says) along the lane. Remember though, it's now in private ownership.

OKEHAMPTON

——— The A30 from Exeter towards Cornwall now thunders past Okehampton along the 'Dartmoor stretch'. Perhaps the town isn't architecturally much to write home about, but it has considerable history, founded by Baldwin de Brionne, Devon's Norman sheriff around 1086; its castle above the West Okement river is ruined but still worth a visit.

Don't go there after midnight if you're ghost-sensitive. Lady Mary Howard's ghost appears in the castle's park at this hour, seeking to complete her punishment for murdering all four husbands. (She didn't actually.) She drives there from Fitzford on the edge of Tavistock in a coach made of her spouses' bones; their skulls mark the roof's four corners. The coachman is headless; a sable hound with single central eye runs in front. Her punishment? To pick a single blade of grass until all have been plucked. As the river walk here crosses green meadowland where people picnic it's unlikely she'll ever succeed.

Enjoy something different on the Dartmoor Line at Okehampton railway station. London & South Western Railway came here in 1871; lines closed as part of Southern Region of British Rail in June 1972 – fondly remembered for its Atlantic Coast Express from the 1920s.

Thankfully this is a partially-reversed Beeching closure. In 1994 Phase One of Okehampton's station restoration began. A model railway museum, video presentation and buffet restaurant now occupy it, while a youth hostel operates in the restored goods shed. The line is run by Bardon Aggregates (for goods purposes) and RMS Locotech; Devon County Council engages trains from Exeter on summer Sundays which link with the Dartmoor public transport network for visiting the Moor.

You can also catch a Dartmoor pony here – without the need for lasso or bunch of carrots. A small steam train with diesel unit

support runs most weekends up to nearby Meldon, where you can find out the quarry's history and walk beneath Meldon Viaduct. W. R. Galbraith and R. F. Church built it; the single line opened over metal girders and lattice piers, spanning 540 feet, about 120 feet up, in 1874. It was soon doubled, using steel, and carried the Okehampton to Tavistock line in an area noted for wildlife – another good reason for riding the 'Dartmoor Pony'.

🌸 OTTERY ST MARY

—— Samuel Taylor Coleridge was born in Ottery St Mary in 1772; he received some of his education, before his clergyman father died, at its King's New Grammar school. The last of 13 children, Coleridge's memorial plaque on St Mary's churchyard wall contains his profile, with hovering albatross – representing *Rime of the Ancient Mariner*. 'Coleridge fever' here is only recent, and is yet to reach the point of exploitation in this lovely Devon town.

I can't help wondering why Coleridge omitted from his description of the bells of St Mary's – 'the poor man's only music' – another tune that came from the church tower when the wind blew. Ottery St Mary once had a whistling chanticleer as its weathervane. The structure, although not original (hardly surprising since it almost certainly dates from the 14th century), still swings here; it no longer whistles.

Two trumpet-shaped tubes ran from breast to tail of this singular bird, which when the wind blew strongly were filled with air and created the whistle. There are doubtless pagan associations with days when cocks were used on buildings to ward off evil spirits; Bishop Grandisson of Exeter, to whom Ottery St Mary owes its exceptional church created as a small version of Exeter Cathedral, said it represented vigilance.

During our Civil War the weathercock received its fair share of battle scars, due it's believed to Fairfax allowing his men to use it for target practice. There are certainly musket ball-shaped holes in the old tail displayed in the north aisle of St Mary's in a glass case. After almost 600 years the weathercock needed restoration in 1977. By then it had long since lost its proper whistle (so perhaps on reflection Coleridge never had the pleasure of hearing it) and a device was fitted to rectify matters.

When put back on the tower it proved so noisy that townspeople protested until the church had the whistle removed again.

Whether Coleridge was acquainted with Ottery St Mary's famous November 5th custom is doubtful; so is the wisdom of carrying a barrel of flaming tar across your shoulders through the town's streets, even if protected with gloves, headgear and copious padding. Predecessors of today's intrepid competitors must have sported singed hair – and worse – for days afterwards.

❦ PAIGNTON

Paignton is a place of 'p's: pier, palace and pudding. Taking the last first, when the railway which brought much of its future prosperity as a seaside resort was opened, the party had as its centrepiece a giant pudding. The recipe – for improbable quantities of anything from milk to raisins – is still marvelled over today; it was baked in eight sections, transported to Paignton Green by horse and wagon – and fought over by those present. Small greasy parcels plagued the local postmaster for days afterwards.

The pier is a product of the town's second 'flowering', bridging that gap between sea and land beloved of Victorians, and now not certain what its role should be – other than a base for rides and slot machines.

Paignton's early importance relates to the presence of one of the many palaces of the Bishops of Exeter who were lords of the manor between 1066 and 1549. An area around the church of St John the Baptist, encompassing Church Street, Tower Road and Palace Place, stands as a reminder of the past. Only one tower in its south-east corner and some castellated red sandstone wall mark the palace itself; within the fortified area someone built a parish hall for St John's. Red sandstone was also used for the church.

The area forms a square, within which is Palace Place, where markets and fairs were held between 1214 and the 19th century – typically, around the church perimeter (the fairs enjoyed a brief revival in 1954). That railways builders' pudding has a connection with Paignton's ancient fairs whose charter is understood to have included a condition that a 'white pot' or pudding should be made and distributed on a regular basis.

If tempted to explore this little-known area of Paignton further – succumb. Down the hill past Paignton Hospital to the main Torquay road, first left (twice) into Littlegate Street brings you to Kirkham House, well and truly hidden at the bottom. It's another of those 'bests': best complete medieval secular building in Paignton and one of the best examples in Devon. Only open on the third Wednesday of each month between April and September (alas) the restored town house displays an open hall over which projects a first floor room.

🌿 PARRACOMBE

—— Parracombe: 'valley of the pedlars' or 'valley marked by enclosure'? In either event, travel much further north as the seagull flies and you'll be in the Bristol Channel. Here is a R. D. Blackmore (*Lorna Doone*) village; some of Blackmore's relations owned property and land around this settlement in a dip below the A39, on an old-established route for chapmen, or pedlars, nowadays more accustomed to walking boots and rucksacks. His grandparents were part of the old church's congregation.

In 1879 St Petrock's church, sited above the village towards Churchtown, was declared unsafe. There had been a church of that name since the 11th century, rebuilt by William de Falaise, with a tower added in 1182 – possibly an act of reparation by one of Thomas à Becket's murderers (like Bovey Tracey's church) – and a 13th century chancel. All was further rebuilt around 1500.

Suggestions that St Petrock's be demolished brought a wave of protests, led by John Ruskin, who offered £10 to start a building fund for a new church on a different site 'if such an act of vandalism' was not perpetrated. Christchurch was erected in Parracombe's centre; you'll pass it just beyond the post office and stores. It's probably easier to park near here and walk up the lanes to St Petrock's if possible, as there's not much parking space in the vicinity.

Nobody who visits will doubt the wisdom of Ruskin's crusade. It's a gem, unaltered for 200 years and typical of an 18th century village church. On a tympanum above the rood screen the Lord's Prayer, Ten Commandments and Creed are painted in panels which also list the churchwardens. At the west end high box pews used by the band of musicians who preceded the introduction of

an organ are tiered like theatre seats. One has a piece cut out for the bass viol's bow. There are even hat pegs along one wall.

Parracombe's old church is cared for by the Churches Conservation Trust; it's usually open. If not, the key is kept at The Haven nearby. Declared redundant in 1969, it became the first in the country to be recommended for adoption by the Trust in 1971, having received several grants – including one from the Pilgrim Trust – to deal with problems arising in the 20th century.

PILTON

Psst! Want to see a backwater of history? Then visit Pilton, where Barnstaple's earliest settlement is believed to have been located. It was the Saxon 'farm by the creek', later a clothmaking community with medieval mills.

Facing the top of Pilton Street are almshouses, dated 1849 but Tudor in appearance. An archway beneath them leads over cobbles to St Mary the Virgin, former priory church and cell of Malmesbury Abbey, which became a parish church in 1536. Except on Sundays take the first churchyard path to the 'Weekday Door' into its south chapel.

Priory buildings once adjoined the east and north sides of St Mary's tower; Pilton Priory was connected with St Margaret's Leper Hospital (yes, another Devon leper hospital – see Great Torrington and Honiton) at the bottom of Pilton Street on the site now called St Margaret's Terrace. An old rood screen, restored in 1988, was first made and painted in 1430 in gold, vermilion and blue; Cromwell's soldiers covered it in white. The pulpit has an iron hand to hold an hour glass and a sounding board over; a plain font is covered by an early spiral canopy in linen pattern – unusual in Devon.

Even the Raleigh family gets in on the act – though not actually Sir Walter – in the south chapel named after William de Raleghe, knight. What is most unusual about this church, however, is that nothing is straight or upright. Pulpit and pillars on the south side lean. The rood screen inclines to the right; chancel and aisles are slightly off-line. Even the chancel roof is out of tune with its stone archway.

Perhaps the builders needed the restorative qualities claimed for Pilton's ancient Ladywell, below the churchyard, reached

down steps beyond the church and housed in a stone building with protective grille. More of the former priory can be found in nearby Bull Lane, where a private house, stone under slate, has been identified as the likely priory lodging wing or guesthouse, updated in the 15th and 16th centuries.

Altogether true hidden Devon; even the church tower has a story, being pulled down 'by force of arms in ye late unhappy civil wars: anno domini 1646' and rebuilt in 1696.

PLYMOUTH

—— What can one write of Plymouth, Devon's largest port, naval city and commercial centre that isn't already well known? It has a lengthy history as three towns – Sutton, Dock or Devonport and Stonehouse – and continues to play a major role in our country's present and future.

The Barbican area, recently rejuvenated to portray Plymouth's past and enhanced by the National Marine Aquarium, and The Hoe offer experiences and opportunities galore. In its shopping centre, laid out after Second World War devastation, even shopaholics find they've met their match.

This country's defences gave birth to a suggestion for an unusual and unexpected aspect of Plymouth to seek out. In Weston Mill cemetery, en route to Saltash, the founding of Sailors Rests in England is commemorated.

Agnes Elizabeth Weston, born in 1840 and the child of a barrister, soon realised that drink and sailors often didn't mix. Beginning by supporting a single sailor with her letters, within three years Agnes Weston's writings were being published monthly, and she was approached by HMS *Dryad* asking for a temperance home for sailors in Plymouth. With her friend Gertrude Wintz, Agnes, or Aggie as she soon became known, opened a shelter in 1876, designed to compete with pubs in its palatial interior, offering hot drinks and food – later baths and a bed for the night. Whether a man was from the Royal Navy, a merchant or foreign seaman or a soldier was immaterial, and although the aims of the Sailors Rest were for spiritual, moral or physical well-being, there was no requirement for religious or moral improvement as a condition of use.

Sailors Rests have become part of forces' life; wives and

Aggie Weston monument in Weston Mill cemetery.

families have also benefited from welfare and social help from the movement begun by 'Mother' Weston. When she died in October 1918, Agnes was the first civilian apart from royalty to receive the signal honour of a funeral with full military honours. She rests beneath a large white memorial angel with an anchor placed against its base near the main entrance to Weston Mill crematorium. 'The Sailors' Friend', proclaims an epitaph to 'Ma Weston', who joked, prayed and wrote letters for sailors,

often breaking up street fights and putting them to bed when drunk. An unusual lady.

🌿 PLYMPTON

—— There are two distinct parts to Plympton: St Maurice or Erle and St Mary. It's easy to miss the amazing layers of history that existed here; as the local verse says: 'when Plymouth was a fuzzy (furzy) down, Plympton was a borough town'. Today it is largely dormitory territory for Plymouth, but delve a little and you discover its origins: even the remains of a castle.

Richard de Redvers received the manor of Plympton Erle from Henry I, by which time the pudding-shaped mound or motte of rubble and earth and a rectangular bailey may already have been thrown up. Within twenty years it fell, under Baldwin de Redvers, after siege by King Stephen and 200 men. The result was a replacement stone castle on the same mound.

Plympton has a record of defying royalty; history repeated itself in 1224 before the castle (and lands around) passed to the Earls of Devon and was improved. A tower at the west end flew the Courtenay family flag but by 1539 only roofless walls remained standing.

It is believed to have acted as Prince Maurice's base in the Civil War, during the Royalist siege of Plymouth. In the 18th and 19th century fairs, circuses and maypole dancing all took place in the bailey; the area still hosts village festivities.

The reason why Channel 4 Television's *Time Team* accepted a challenge in January 1999 to investigate the early history suspected to lie behind Plympton's frontages becomes evident as you descend School Lane into Fore Street, filled with old buildings. Guildhall at No 42, dating from 1696 and pillared, is still used for local events. The arms of Sir George Treby and the Strode family, both of whom had great influence here, are carved above its doorway. A mix of 17th and 18th century houses and the old grammar school in nearby George Lane, founded in 1658 and now the Sir Joshua Reynolds Centre, all speak of Plympton St Maurice's former importance. This eminent painter received his education here – where his father was master.

Who owns the castle today? It was vested in the ownership of Plympton's parish council in 1922 on behalf of its people, who

are fortunate to inhabit an oasis of history in a desert of modern suburban housing.

POWDERHAM

Powderham – or rather its castle – has been the home of the Courtenays, Earls of Devon, since 1391, 56 years after Edward III gave Sir Hugh the first earldom. It was a 'younger son' Courtenay, Sir Philip, who began the present building of which the Great Hall and its surrounding area and the north tower are still original.

You could hardly feature Powderham Castle as a 'hidden' or lesser-known attraction; it's difficult to miss either from the Exe estuary or from the A379 and rightly attracts thousands of visitors annually. My husband acts as a tour guide there and enjoys the special atmosphere that a stately home where its family really live imparts.

A less familiar feature which can be visited – outside the shooting season – from within its grounds was built in 1773 by William, the second Viscount, in order to allow his 14 children to pursue painting and music. (In case you're wondering where the son and heir fitted into this extensive progeny – he was number eight.) In arranging for a belvedere to be raised in the parklands above the castle, William Courtenay was creating a folly (like Haldon Belvedere near Dunchideock – built slightly later) modelled on Shrub Hill in Windsor Great Park.

Unlike Haldon, or Lawrence Tower as it came to be known, Powderham's folly is of rendered red brick with hexagonal turrets. It has three floors, which included a small ballroom with floor-to-ceiling windows. The terrace outside has long since vanished. Its story has a less happy ending than Haldon Belvedere. Gutted by fire at the end of the Second World War, a ruined shell awaits restoration. Plans exist to convert it; death duties and the massive costs of maintaining castle and estate have so far prevented their use.

Belvedere Walk leads from the recently developed Secret – once Woodland – Garden uphill towards the tower, proving that the second Viscount knew what he was doing when he sited it there. Imagine the noise 14 children can generate!

RATTERY

——— Where had the nuns gone, I wondered, as I left the A38 Devon Expressway to drive to Rattery. Marley House, once home to Robert Savery, to the Palk family and the Carews of Haccombe (in 1824), was notable for housing the only English community of nuns with an unbroken line of service since before the Reformation. Following the dissolution of most priories the Bridgettine nuns of Syon Abbey fled to the Continent and returned to Dorset in the late 19th century. The Order, founded in Middlesex in 1415, arrived at Marley House in 1925 from Chudleigh, also in Devon. I found it a shock to see signs for Marley House Country Estate, which appeared to have been split up and 'tarted up', to put it bluntly.

Rattery village itself, once within the Marley Estate, has a particularly interesting inn. Church House, next door to the church of St Mary the Virgin (appropriate for an area with an order of nuns) traces its history back to AD 1028; by repute it is the oldest inn in Devon. Monks lived here while St Mary's was being built, making Rattery's building more than an inn merely owned by the parish.

It remained in church hands until 1946. The long white building with slate roof has the usual large fireplace inside and is a popular venue for lunchtime gatherings. A list of vicars dating back hundreds of years – once part of the inn's fabric – appears to have recently been moved into the church itself. While tracking this down, I found an interesting connection between Rattery, its Church House Inn and the memorial plaque to one Pilot Officer Ernest Wakeham.

The pilot officer, who died serving his country, like Francis Steer and Jack Green (two other names on the memorial) is claimed to have invented the RAF slang word 'prang'. Whilst playing darts in the adjoining inn, he adapted the Devon dialect word 'prong' – hay fork – to describe hitting double top. 'Wizard prang' soon led to crashes in RAF talk also becoming similarly known. Ironically, one of these probably led to his death.

And the nuns? In some converted farm buildings on the lower Marley Estate Mother Abbess Ann-Marie and her nuns are continuing their long tradition at Rattery.

ROUSDON

See **Combpyne and Rousdon**.

RUNDLESTONE NEAR PRINCETOWN

Princetown village was named for the Prince of Wales who became George IV. Thomas Tyrwhitt colonised the remote area from 1785, creating the Plume of Feathers Inn (in George's honour) along with the rest of the village; it's hardly a town, despite Tyrwhitt's hopes.

Nearby Dartmoor Prison was built to house French and later American war captives; in 1850, being redundant, it opened for convict use. Early prisoners even built a local church: St Michael and All Angels, first used in 1814.

Today Princetown's High Moorland Visitor Centre is a tourist magnet – rightly so. It offers exhibitions, advice, maps and plenty more. My choices lie outside Princetown itself, off the road from Postbridge near Rundlestone. One is almost 500 years old; the other, found within 300 yards of it, a mere infant.

The pilgrimage to Fices Well is around half a mile across two fields following a clearly indicated footpath. John Fitz and wife, well-known in Tavistock, riding over Dartmoor in the 1560s claimed they were pixy-led. (Moorspeople will tell you this happens frequently.) Lost among the Moor's infamous mires, they stopped to drink at a spring; the act broke the pixy spell and immediately Fitz knew where he was.

He was a superstitious man, said to have asked the midwife to delay his son's birth by an hour to put him in a 'better conjunction of the stars', and vowed to mark the spring, as an aid to other travellers. A granite structure certainly exists where it reaches the surface close to the Blacka Brook, marked with '1568' and the intertwined initials J and F.

The unexpected bonus was to discover a mere 150 yards from the road a Millennium Touchstone. Erected by Dartmoor Prison in 2000, its very presence is unusual. The National Park Authority, who granted permission for the erection of this traditionally shaped stone, normally precludes modern structures on Dartmoor.

Verses on it were written by John Powls, until recently governor at Dartmoor Prison – or Princetown Jail if you prefer:

> 'Inspiring this stone, touching open moor and
> sky,
> Granite landmark raised to stand for all times as
> one time;
> Now, then and ever in love and beauty.
> Our story is a book always open at the centre,
> Half of experiences, half of un-named hopes.'

SALCOMBE

Possibly Devon's ultimate 'messing about in boats' place, Salcombe is the most southerly town in the county. Its mild climate, being south-facing, makes it a popular place all year round – except when trying to find a parking space, which can be the very devil in summer. Salcombe harbour is believed to have inspired Alfred, Lord Tennyson, staying at The Moult with a Mr Froude after illness in 1889, to write his poem *Crossing the Bar* soon afterwards.

> 'Sunset and evening star,
> And one clear call for me;
> And may there be no moaning of the bar
> When I put out to sea.'

My parents' generation all learned this one at school, especially if they lived near the coast.

Shadycombe Creek area still has traditional boatbuilders and repair yards. You can sail, row, hire or own a boat – even take a trip up to Kingsbridge, if the tide is right. *Baltic Exchange*, Salcombe's Tyne class lifeboat is kept in the water nearby and reached by inflatable. RNLI's shop and museum are a visible presence on shore, but where did Salcombe's story of lifeboats begin?

To find out the answer, walk, drive or in summer travel by ferry boat over to South Sands. One of two sandy beaches on the Salcombe side, it is very popular for bathing, digging or just sitting; if walking, visit North Sands en route and pass The Moult, where Tennyson was inspired. Arrive by ferry and a strange contraption

meets your boat: a cross between tractor and cart, with a 'v' into which the bow fits to allow easy transfer to the beach.

A stone building on South Sands now used by Tides Reach Hotel as its boathouse and by Island Cruising Club, has the date 1869 over its door. Red sandstone, curved gables and finials make it distinctive – so do the remains of a ramp in front. Mr R. Durrant of Salcombe gave this building as a lifeboat house for Salcombe's first boat *Rescue* (1870) and its successor *Lesty* – named after the donor (in 1888).

When and why did the RNLI close it? In 1925. By 1930 lifeboats had become more sophisticated and Salcombe's boat anchored in 'The Bag'. Judging by today's beach and that 'sea creature', they'd never get *Baltic Exchange* off South Sands.

SALCOMBE REGIS

—— Look out for thorn trees in this coastal village. One was planted here in Saxon times and local legend says that if it disappears the village will cease to exist. I think there are probably enough at the nearby Donkey Sanctuary, founded by Elisabeth Svendsson, to ensure Salcombe's future. Nowadays the village is reduced to church, houses and holiday accommodation – and a golf range behind a small garage.

Salcombe Mouth has associations with smugglers, part of the notorious East Devon trade which often used church property to hide contraband. A trade of a more grizzly nature – wrecking and scavenging excepted – took place on one occasion in St Mary & St Peter's churchyard: bodysnatching.

It was a disappointment to learn from one of today's parishioners that the huge bolt holding down one of the lychgates had been replaced within living memory, but interesting to see its shape. Its predecessor was evidently a body snatcher's tool known as a 'resurrection corkscrew', which would have looked very similar.

In the mid 19th century two Sidmouth surgeons named Hodge and Jeffery, accompanied by a labourer, set off for the remote church at Salcombe Regis armed with this giant corkscrew-like gadget. It allowed easy removal of the end of a coffin, thereby reducing the amount of digging needed to acquire the contents for 'scientific research'. The grave of a

young lad named Barnfield was targeted; unknown to the trio his parents lived in a cottage adjoining the churchyard wall.

A sudden peppering from a blunderbuss fired over the boundary found its mark. Dropping everything including the resurrection corkscrew the surgeons fled back to Sidmouth over Salcombe Hill to High Street, where Hodge lived. He spent most of the night removing pellets of shot from his colleague, being barely marked himself.

The report of this event came from the diaries of one Peter Orlando Hutchinson, a Sidmouth personality whose painstaking recording of life in the town and its surroundings spared no one. What puzzles me is that there is no indication that the medical gentlemen were ever prosecuted.

SAMPFORD COURTENAY

—— When rector William Harper opened his prayer book on 9th June 1549 in St Andrew's church he was about to spark off a huge insurrection. This attractive cob and thatch village which rises to its church, and the adjoining church house, is where the Western or Prayer Book Rebellion began.

A young King Edward VI and his advisers decided to bring in a new Book of Common Prayer, translating all services into English. Various articles and liturgy were also changed. They made a bad mistake in choosing Whitsun; as it was a traditional holiday for agricultural workers people had the opportunity to band together and rebel.

At Sampford Courtenay the congregation insisted William Harper must revert to the old Latin mass next day (which he did). When a Church Ale was held in the church house, with drinking, archery and other games, discussions got out of hand. Four gentry arrived to enforce the new Act of Uniformity and restore order, but had to withdraw. William Hellyons, yeoman and local JP, was attacked by farmer Lethbridge with a billhook and lynched by the mob.

Villagers marched to join Cornishmen and others in open rebellion and were among those who skirmished at Crediton and took part in the siege of Exeter on July 2nd before the uprising was finally quelled. Many other Devon towns and villages were involved, notably Clyst St Mary.

Sampford Courtenay's church house, like many others, combined business and pleasure. Upstairs is a courtroom used for manor courts. Sampford's building, which still has a roof with jointed crucks and the customary open staircase outside, has been a poorhouse and school during its history. The building was altered to accommodate a master's house adjoining for the latter. One part continues to act as private dwelling – the rest has communal use.

Inside St Andrew's church a 450th anniversary exhibition explaining events in 1549 has been retained as a permanent reminder. Somehow this village doesn't typify a hotbed of rebellion today – but who knows what lurks beneath the surface after a few ciders in its 16th century inn?

SANDFORD

Baronet Sir Humphrey Phineas Davie of nearby Creedy Park gave a school to his local village in 1825, built in the form of a Greek temple. Unusually it remains the local primary school and stands opposite St Swithun's churchyard, in the centre of Sandford.

Its impressive pillars – the Doric columns were originally for an open colonnade – belie the material chiefly used by William Edwards, mason, John Emes, carpenter, and John Kendall, sculptor. This is a school built mainly of cob, and may boast the highest cob walls in Devon. 'Sandford School' and the date in Roman numerals appear above the pillars.

The architectural model which Sir Humphrey commissioned (as his builders were unfamiliar with Greek temples) was later handed over to the school by successor Sir Patrick Ferguson-Davie. It was a free school in which as many as 250 children were once taught. These days, rather fewer pupils need an extra classroom in the playground.

The Davie family were descended from Exeter merchant John Davie, who built the first house at Creedy Park around 1600 in 370 acres of land. Their continued patronage and connection with Sandford was extended to the church, where John Davie had a west gallery built from Creedy Park oaks. St Swithun's had a chequered early history, depicted in a Tudor panel on a north aisle pillar. Following the fight between two men during mass in Henry I's reign one was killed, resulting in closure of the church

Sir Humphrey Phineas Davie's school.

by the Bishop of Crediton for over ten years. The carving, of two children pulling each other's hair out, hardly seems adequate for an act of murder – or at best manslaughter.

There are no longer Davies at Creedy Park, which in 1982 was converted into 13 units of housing. A fire in 1915 had forced the family to rebuild the original, once prosaically called Newhouse, using a Tudor style of architecture. One of Mid Devon District Council's excellent walks based on Sandford passes a viewpoint near its West Lodge, although the house is largely hidden by trees.

Visitors to Sandford in mid July are sometimes surprised – or worried – to be offered a 'Pig's Ear' at its Revels, which evolved from their old St Swithun's Fair. Panic not: you will simply be eating a traditional shortbread biscuit.

SEATON AND AXMOUTH

Seaton and Axmouth border the East Devon river Axe, where it reaches the sea. The former was a Roman port with salt

pans in the Axe marshes; salt officers are mentioned in early church records here.

Before its extension to Exeter, Axmouth may well have marked the Fosse Way's southern limit. Today it is a village with two inns, a church and a small school. Across the Axe, neighbour Seaton has developed into a holiday resort, visited by Francis Kilvert in the early 19th century and recorded in his famous diary.

When the railway reached Seaton in 1868, aiding the town's popularity for days out, crossing the Axe easily suddenly became desirable. The result was Philip Brannon's bridge, commissioned by landowner Trevelyan in 1875, visited by bridge lovers in recognition of its unique claim: to be the earliest mass concrete bridge remaining in England. Opened in 1877, it was then third in the pecking order – the others have since gone.

Looking at Seaton Bridge it's difficult to believe this is a concrete structure; Brannon so carefully ornamented it with indentations that it resembles stone. There are three spans, the centre being widest at 50 feet, still topped by old gas lamps. Not bad for a man who began, like his father, as a printer and engraver.

This was a toll bridge, charging one penny to pedestrians to recoup building costs; a concrete toll cottage, single storey with a curving roof, used to occupy one end – abandoned by 1907. Two advantages of its replacement in 1990 by a flat bridge are that you can walk across Brannon's original unhindered by traffic, or sit below it on the riverbank for a better appreciation of 19th century ingenuity.

To follow the Axe upstream, seek out Seaton Tramway behind the seafront, where old trams of all descriptions use the former railway line, cross the A3052 at Colyford and then continue inland to Colyton. Your reward? Reedbed and estuary birds galore, as well as herons.

A tip for would-be visitors to Seaton from the west: ignore the first signposts and make your approach via Axmouth. As you descend the steep hill beyond Seaton Down towards the panoramic Axe valley you'll see why it's a firm favourite in our family for impressing Devon-sceptics.

SHALDON

The two old villages of Shaldon and Ringmore were annexed to Teignmouth in 1881. To connect the former to its

larger neighbour there is a ferry across 'The Salty', also Shaldon Bridge – a wooden bridge, mostly replaced by one in iron. Shaldon lies on the A379 from Torquay; approach from this direction for a panoramic view eastwards into Dorset.

You will also pass Shaldon's strange 1828 toll house, built in two storeys, presumably to take account of different levels on the roads from Torquay and (via the bridge) Newton Abbot. Much of the village lies towards Shaldon Ness and the open sea; holiday needs are reflected in bed and breakfast accommodation, gift shops and cafés among everyday shops and a post office.

The main street becomes the Strand, where houses were originally built by the Newfoundland Fisheries Company for fishermen's families. Large swathes of Devon's coasts sent ships and men here from the 16th century to fish and salt-preserve cod. Several wealthy Devon families made their money by building and supplying ships, workers and necessities for life in Newfoundland.

I suspect that the properties are rather better than when used by fisherfolk; interestingly the tiny gardens which were established beside the river Teign's beach across the road remain. Shaldon is definitely a place to delve into back streets. Behind the Strand are typical houses and cottages of a seafaring town. It's well worth walking into Riverside behind the main road and onto Shaldon's waterfront, beside Tudor House, whose walled garden backs onto the river. Many of the old properties here cry out 'warehouse' or 'ship's locker' as you pass. Some have square overhanging first floor bay windows, with a similar Dutch influence to those on Topsham's Strand on the river Exe perhaps?

Something is always happening on the beach or in the river whatever the season and if the red Shaldon Ness, where Teign meets sea, or the delights of gardens opposite the Ferry Boat Inn with its old bow windows aren't enough, there are botanical gardens to visit, with their own parking in season, alongside the Torquay road.

SHAUGH PRIOR

The suffix 'Prior' connects Shaugh with Plympton Priory; parts of its church of St Edward King & Martyr date from the 11th century. Inside this typical Dartmoor granite building a towering

late medieval font cover bears eight carved priests, surmounted by a bishop in mitre holding his pastoral staff. Like many such treasures it was discarded during an 1858 restoration and thrown into a local linhay (cattle barn). Several times the farmer's wife suggested the 'rotten old thing' should be burned. Luckily a later incumbent recovered it and sent it to Exeter where, at Mr Harry Hems' famous workshop, its several storeys were restored.

In truth Shaugh Prior is worth visiting for its setting alone. Standing outside the churchyard on a high bank the view stretches towards Plymouth Sound and into Cornwall. Below the village lies Shaugh Bridge, in the tree-lined valley of the Plym. There are two bridges here: one for cars, the other for pedestrians only. Between them the Meavy joins the Plym as it rushes over boulders beneath the trees. A small car park makes it easy to sample riverside walks (though it must overflow onto the narrow road in high summer).

One such walk leads to the Dewer Stone: a near vertical granite face on which Plymouth poet N. T. Carrington's admirers carved his name. Carrington, who also has a memorial in St Edward's church, wrote *Dartmoor: a descriptive poem* intending to enter for the Royal Society of Literature award in 1824. Something delayed him; luckily George IV liked it so much he gave him 50 guineas anyway.

The Dewer Stone has given birth to another series of Devon tales. Dewer the hunter (alias the devil) and his wisht hounds enjoyed their own form of the chase. Leaving Wistman's Wood – a curious area of gnarled tree trunks and, they say, vipers – he and his hounds would seek out a victim, pushing them to the Dewer's very edge until in panic he or she flung themselves off. The hunter rides a headless black horse; his hounds have 'scorching red eyes'. Difficult to believe on a sunny day, but not so hard during a Dartmoor fog!

SHEEPSTOR

Devon has long been a popular retirement spot. Rajah James Brooke, for example, retired to Burrator House at Sheepstor around 1859. He was the first of three 'white rajahs' of Sarawak. Following service with the East India Company's civil service and in their army, where he was wounded, Brooke

travelled in the Far East, commissioned to take gifts to the Rajah Muda Hassim of Sarawak.

The area was torn by insurrection and plagued by pirates; Brooke decided to remain and help local administrators sort matters out. They later implored him to stay and offered him the position of Rajah. Queen Victoria knighted Brooke for his efforts in 1848 and, when he visited England to receive this honour, James took his nephew John Brooke Johnson back East, proclaiming him Rajah Muda – his heir.

Unfortunately both men died in 1868, but another nephew, Charles Anthoni, had already left the Royal Navy and been named Tuan Muda (young lord or heir presumptive). The line continued through him for a further 50 years, being passed to his son, Charles Vyner de Windt Brooke – who finally ceded Sarawak to Great Britain after the Second World War. His brother Bertram had been created Tuan Muda at birth; neither he nor Anthoni (Bertram's heir) succeeded to title of Rajah.

What legacy of the Brookes remains in Sheepstor? In St Leonard's churchyard, on its north-east side in the shadow of the tor are a series of graves, enclosed by railings that bear the crest of Rajah James Brooke and his motto 'dum spiro spero' – 'while I live, I hope'. A red Aberdeen granite sarcophagus encloses his bones; a Dartmoor granite boulder, quarried on Sheepstor and drawn to St Leonard's on eleven horses commemorates Charles Anthoni. Granite also marks the resting place of the third white rajah, while a small plaque has been raised to Tuan Muda Bertram.

Inside the church are more memorials to the Brookes and a Tua Kumbu, or ceremonial blanket, recently brought as a pilgrimage gift from Sarawak.

Sheepstor is close to Burrator Reservoir, which opened in the 1890s to supply water to Plymouth. Extended in 1928, its capacity is up to 1,026 million gallons. Parking places just beyond its bridge offer pleasant views and starting points for walks beside the water.

SHERFORD

The church of St Martin at Sherford is described as 'slate inside and out'. Delving into narrow lanes beyond East and West Charleton, where slate was famously quarried for Dartmouth

Castle's square tower in 1488, I pondered whether there were good medieval deals offered for large quantities.

Sherford manor belonged to the abbey church of St Olave in Exeter. St Martin's itself was finally consecrated by Bishop Lacey, of Exeter, in August 1457, significantly after the curacy of John Reynell some 35 years earlier. Reynell was warned by his rural dean to obey his vicar, which suggests he'd been taking advantage of the remote location to conduct affairs after his own fashion – a typical Devonian in other words.

The rood screen here was whitewashed – or at least its paintings of apostles were – and not rediscovered until renovations after the Second World War. Elizabeth I had the top lopped off the screen, as part of her purge against Catholicism. Externally at least, it's only the window surrounds – featuring sandstone dressings – which aren't made from slate, though not the thin stuff we see on roofs.

There were three Domesday estates in the area around Sherford: Keynedon, Malston and Stancombe – home to Roger de Stancombe until 1241, when it passed to Gilbert Crispin and was renamed Stancombe Crispin in his honour. When Nicholas Dawnay acquired it, Crispin became Dawnay. Confusing for the locals, who must have been quite relieved when it settled by marriage in Courtenay ownership – only to find they were transferred first to the Champernownes of Modbury, then Pollixfens and Jellards. Eventually the main manor house, with parts dating from before 1086, was purchased by a London architect and his wife, who have converted Stancombe Manor into a holiday complex.

SIDBURY

You may visit Sidbury to admire its church; don't expect to use the 'powder room' at St Giles' – it won't be quite what you'd expect. Sidbury's powder room was actually used by priests, built above the porch and converted to house muskets and powder – like many such – when men were retained to defend an area in times of trouble. Nowadays it is home to the village archives.

Sidbury is very old; the hill to its west is likely to have been a fort or castle in Iron Age times, on trade routes to and from the

Bristol Channel. It was on Castle Hill that women of the village paraded in red cloaks to persuade the French that its fort was manned by soldiers in Napoleonic days.

The village had two mills, mentioned in a 1281 survey as being valued at 300 shillings. One was evidently used for fulling, the other for corn. Known as Town and Manor Mills, they feature in early 19th century records under the ownership of the Westcotts, although parish history claimed that in 1795 both were 'damaged by fire'. Despite this, miller Samuel Westcott managed to grind corn that year and take it to St Giles' church by cart, where it was sold at a subsidised rate to the village poor. Were the contents of that powder room needed to help retain order?

'Manor Mills' was advertised in the 1830s as a 'capital water-mill with two overshot wheels, turning three pairs of stones'. It had two storeys above a ground floor which housed the mill gear, a pound house mill, stables, gardens and an orchard. The mill continued to turn until 1969, latterly turbine powered. Today it is being restored by John and Judith Stephens. The reinstalled waterwheel turns one pair of stones, using its 1930/40s machinery for milling flour. With additional machinery being added, an art gallery and tearooms, Sidbury Mill is worth visiting. Its leat runs to the overshot wheel or diverts down a race into the nearby stream and thence into the river Sid, less than half a mile away.

SIDMOUTH

—— Love or loathe the East Devon seaside town of Sidmouth, its architecture bears out the title of Devon's Regency Town.

In this sedate resort at least one property might have led to Sidmouth being ostracised by royalty. Royal Glen Hotel – formerly Woolbrook Cottage – housed the infant Princess (later Queen) Victoria, who visited with her parents the Duke and Duchess of Kent in the winter of 1819–20. Not only did the Duke take a chill and die within its walls, Victoria herself narrowly escaped death from a stray catapult shot, aimed in its gardens by an apprentice lad. If you ask nicely, the owners might well show you the window he broke, formerly of Princess Victoria's nursery.

These events actually helped popularise Sidmouth, attracting royalty on pilgrimage. Victoria's third son, the Duke of

The old boathouse in Connaught Gardens.

Connaught, fell in love with it and decided in 1931 to winter here rather than on the Continent (in deference to Great Britain's Depression). His equerry was friendly with Col Balfour, Sidmouth's Lord of the Manor, on whose behalf the Fortfield Hotel was run. Where else should Arthur, Duke of Connaught stay?

His lordship enjoyed selecting fish straight from the boats for the Fortfield's chef to cook. Many relatives visited him here, including Princess Ingrid (later Queen of Denmark), during the years 1931 to 1934. On his arrival for a third stay, Sidmouth Urban District Council asked Duke Arthur to open new gardens at the foot of Peak Hill, which they wished to name after him. He performed the ceremony on 3rd November 1934.

Did the Duke know that these gardens above Jacob's Ladder beach were on the site of Cliff Cottage, where murderess Constance Emily Kent was born in 1834? Stories of her mother's madness were rife in Sidmouth, forcing the family to leave town. In spite of a name change to Sea View the property remained

unpopular; elderly Sidmothians remember running past its walls holding their collar against bad luck.

An elaborate boathouse remains with a chiming clock – now a café where Devon cream teas are eaten al fresco. Why a cliff-top boathouse? There was no space for one below; boats were launched and retrieved on davits.

SLAPTON SANDS

Strete Gate, whose spelling may well only have changed around 1870 to avoid confusion with Street in Somerset, marks the beginning of a causeway behind Slapton Sands and in front of the marshes which become Slapton Ley. There is a car park and picnic area here with a woodland walk; its walled area marks the grounds of Strete Gate manor house, later Slapton Cellars and finally Royal Sands Hotel: one of several places in Devon that Edward VII allegedly visited as a boy.

The hotel had already suffered from damage in 1940 after a stray black and white dog (locals say he was called Pincher) ran into a nearby minefield; in July 1943 it was requisitioned along with the entire area at six weeks' notice, for US practice for the D-day landings. During exercises in 1944 further damage rendered it derelict; the hotel was flattened after peace was signed. A Leslie Thomas novel *The Magic Army* centres on the occupation of Slapton and its surrounding area – well worth reading, and where better than among the 300 trees that were planted here at Strete Gate?

A sad modern tale of demolition on this lovely if wild stretch of coastline happened in millennium year, when a monument to the United States' involvement, presented in July 1954, was destroyed by the sea's action – along with a section of the causeway road. In October 2001 all that stood was a plinth and two flagpoles.

Fortunately other memorials in the car park in Torcross at the southern end of Slapton Sands and the Ley, in the form of a Sherman tank lost during the practice landings and recovered in 1984, and plaques remembering Operation Neptune and Exercise Tiger, seem unscathed. 'All honour to their names' concludes a rough-hewn granite stone, whose plaque shows men from two tank landing ships pulling others from the water.

Behind them Slapton's Lower Ley – the largest natural lake in the West Country – is placid by contrast, among its marshes and reedbeds. On the banks nearby a small hide encourages disabled access to view the Torcross Duckery project.

SOUTH MOLTON AND NORTH MOLTON

South Molton represents 'G' in *North Devon Alphabet of Parishes* as 'Gateway to Exmoor'. With a huge pannier market doubling as a car park on non-trading days, and an impressive livestock market drawing heavily on Exmoor and North Devon in general for stock, the town has tremendous atmosphere – and several buildings of interest.

In an alcove above its Town Hall – designed by Cullen in the mid 18th century – is the bust of town benefactor Hugh Squier (1625–1710), younger son of yeoman William Squier of Townhouse, to the west of South Molton. Hugh left home knowing that elder brother Christopher would inherit and like many entered a London merchant's office before 'doing a Dick Whittington'. One thing his money couldn't buy was healthy children; he and wife Elizabeth lost four then decided to spend some of their fortune charitably instead.

Christopher Squier had meanwhile inherited Townhouse and made settlement of tolls and duties from two charter fairs and from regular South Molton markets to Hugh who, on Boxing Day 1682, decided to endow a school for the town. It should be in the churchyard, he decreed, for 150 boys of whom 20% must be given free education. He gave detailed instructions about the buildings and its educational ethos: 'not a horn book school, nor for common Latin alone'.

The school was actually opened by 1686, not in the churchyard but at lower East Street in an area which later housed some of the town's mill owners. A schoolmaster's house was included, as well as writing and Latin classrooms. The 30 poor boys (Squier's 20%) were taught good writing and arithmetic. Among pupils at Hugh Squiers School – later part of the Blue Coat School until 1877 – was *Lorna Doone's* author R. D. Blackmore, before he moved to Blundells in Tiverton.

Hugh Squiers' old school is now called 'Tamarisk', a private house purchased by Samuel Brown for a private school when

South Molton's United School opened. It was the headquarters for the North Devon Yeomanry in the First World War and a honey farm – at which point one third was demolished to allow lorries to enter the grounds.

For those who feel that every South has a corresponding North: North Molton lies north of the A361 North Devon Link road, a small town formerly noted for its iron, lead and copper mines and wealthy during Devon's woollen industry heyday. All Saints' church and its Square are worth a visit.

SOUTH TAWTON AND SOUTH ZEAL

These Dartmoor villages shared a parish and at least one significant facet of their history through the Oxenham family. South Tawton claims the family seat between the 13th and 19th centuries, and family memorials in St Andrew's church; South

Church house, South Tawton.

Zeal has the Oxenham Arms inn, dating from the 16th century, owned by the Oxenhams.

The legend of a white bird resembling a thrush with horns on its head, said to appear when a member of the family was likely to die, is well documented. This bird, probably the charadius or caladrius of medieval manuscripts, symbolising Christ free from all sin, is known in Devon as a 'fetch'; it is believed to be a former Oxenham in bird form.

In appearance these are very different villages, South Zeal, built into a hill with several shops and a thatched post office, has an interesting chapel with medieval origins – possibly as a weavers' guild chapel. Following 18th century rebuilding it was a school for 110 children, until succeeded by a council school when after further restoration it became St Mary's chapel of ease for the parish of South Tawton around 1877.

Outside, St Mary's has a small belfry with 'wheeled' bells and a puzzling clock with faces at both ends of the building. Inside, it's clear that the driving shaft for the latter runs under the roof; the clock's loud tick marks the passage of services. A large and ancient cross, 18 feet high and believed to date from the 14th century, in the small churchyard has recently been dismantled and restored to its former glory by Dartmoor National Park Authority – one of the finest examples in Devon.

Talking of old stones, there's a menhir concealed in a small room behind the bar at the Oxenham Arms inn. Its top reaches the ceiling and nobody's dared investigate how far it goes below the floor. *Pickwick Papers* is said to have been written in this inn when Charles Dickens was caught in a snowstorm in 1836. In a further literary claim, it is the setting for Eden Philpott's novel *The Beacon* (1928), St Mary's clock and bells are romantically praised: 'A shining clock beamed from the chapel ... two exposed bells hung together in a tiny turret and at times twittered together thinly like birds ...'

South Tawton's most interesting area surrounds the church; a thatched church house with double steps in front adjoins the stile into St Andrew's churchyard beside the lychgate. In use for five or six hundred years by the parish – and still buzzing last time I visited – it stands close to an oak tree set within stone walling and seats, where a tree has stood since Queen Elizabeth I's reign. Among useful pieces of information to be gleaned from several plaques is the name of H. A. Hore, whose family took

over Oxenham (now a farmhouse), and an approximate dating for the present oak tree of 1984. Its predecessor was an elm, which caught Dutch Elm disease.

STARCROSS

——— A ferry has ploughed across the Exe estuary at its lower end since Sherborne Abbey's monks used it in the 12th century. Coaches were taken over, while it was still a rowing boat, with two wheels hanging over the end to counterbalance the weight. Fresh sets of horses were kept on either side. How much luggage ended up on the seabed is impossible to guess.

Starcross was once Staircross, say some locals, after a cross which stood at the top of steps leading to the ferry and was touched by travellers for luck. No sign of one today, but Starcross has another transport secret to divulge which marks an unusual failure for Isambard Kingdom Brunel, engineering genius. Close to the inn named after the Courtenay Earls of Devon is an Italianate red brick building on the waterside, now used as headquarters by Starcross Fishing & Cruising Club and renamed Brunel Tower.

In this house Brunel built a pumping station in the 1840s for the atmospheric railway he thought would use pressure from the earth's atmosphere to power trains. People expected this idea to supersede steam engines. A piston fitted into a tube, laid between rails and sealed with a level valve. Along stretches of railway, stationary engines pumped air from the tube every few miles creating a vacuum which drew the piston and thereby the train's carriages forward. Sounds unbelievable? Think of the system once commonly used in shops to transmit money to a central cash desk; it's the same principle.

Shareholders who were initially jubilant reckoned without the intervention of rats, who chewed the leather valves, attracted by the grease used to seal them. There were too many breakdowns; in 1848 Brunel abandoned the idea. The pumping house was briefly opened as a museum to atmospheric railway history, further information can be seen in the GWR Museum at Newton Abbot.

Despite frequent incursions by the sea the railway still daily passes Starcross, where sailing boats dance on the water and Exmouth's new dockside houses grow in multi-coloured hue on the river's opposite bank.

STOKE GABRIEL

Bells rang out across the creek as we parked on Stoke Gabriel's quay; its dam was uncovered by the tide and populated by swans, trees were changing colour – typical picture postcard stuff.

Stoke Gabriel was noted for its salmon fishery; netting rights here are still jealously guarded. Steamers once came from the river Dart, to unload at its quay; there was a tide mill with sluices and mill pool – of which the dam was an integral part. What happens here nowadays, apart from visitors admiring the view and perhaps strolling up the slope to eat at the Castle Inn (sitting outside on 'the Battlement') or at Church House Inn? Stocks outside the latter invite donations for village funds if you want to be photographed in them.

This is a very lively community with organisations galore. They all have boards near the village car park, offering anything from playgroup to boating, via sport, art, church organisations and British Legion. Shops include a mixture of tourist fare and the more practical; the post office trebles with gifts and a delicatessen.

A cobbled path leads from Church House Inn to St Mary & St Gabriel's church, whose massive ancient yew in its full churchyard is well over 1,000 years old. With well-supported boughs, some touching the ground, it is believed to be the largest in Devon and is certainly the biggest I saw on my travels.

If it's not in use for a service or some parish gathering, go inside St Mary & St Gabriel's and admire the 15th century rood screen, with paintings of apostles and prophets. Alternatively a stroll around the perimeter rewards one with another prospect of the waterside and some light reading on tombstones. I was hunting for evidence of the Churchward family; there was plenty including several Marys, although I didn't find an inscription for George Jackson Churchward, born at Rowe's Farm in the nearby hamlet of Aishe. George, who attended Totnes Grammar School before taking up an apprenticeship at Newton Abbot railways works, eventually rose to the position of Locomotive Superintendent for the Great Western Railway. Ironically, he died at the 'hands' of a railway engine near Swindon in Wiltshire, after his retirement.

TADDIPORT

See **Great Torrington and Taddiport**

TAVISTOCK

I wonder whether Sir Francis Drake enjoyed cream teas. The great circumnavigator and Armada commander was born south of Tavistock at Crowndale Farm in 1545, though he pops up all over this part of the county, in East Devon near my home, and is 'claimed' elsewhere.

We know he had two wives: Mary Newman (1569) and Elizabeth Sydenham (1585); the latter was 20 years younger than Drake. When the Spanish Armada was approaching he refused to move until his game of bowls was ended – a tale spoiled by naval historians who say there was a south-westerly wind blowing and the tide was also against English ships leaving Plymouth Sound at the time and *that's* why Drake stayed.

On Plymouth Hoe is a statue by Boehm of Sir Francis – but that statue's only a copy. Where's the original? In Tavistock, where most people drive past him. They do say poets are without fame in their own country. Look for it, surrounded by railings (to prevent vandalism) and traffic, on the Plymouth road close to Drake Villas, near where it crosses Tavistock's disused canal.

It was erected in 1883 by the Russell family's Francis, seventh Duke of Bedford (Tavistock's main landowners). The Russells made a fortune through tin, cloth and copper (especially as Tavistock was a stannary town for assaying tin), but were at least prepared to spend some of it improving and enriching Tavistock, as buildings here prove.

'Dice' with traffic and take a closer look. You'll find scenes from Sir Francis Drake's life in panels around the base of his statue. A good time to examine Tavistock's original might be the second Wednesday in October, when the town's traffic grinds to a halt for its famous Goosey Fair dating back to Sir Francis' lifetime.

And that cream tea? Monks at Tavistock Abbey in medieval times – who provided Tavistock's earliest influences and obtained its first fairs charter in 1116 – were well versed in the art of

scalding milk to make clotted cream centuries before Francis Drake's father became a farmer at Crowndale. He's bound to have grown up with clotted cream on those famous tonsils – isn't he?

TAWSTOCK

Clear directions to one of the most fascinating churches in Devon from a wooden village sign indicate a dead-end, but don't be deceived. En route, you'll find a real hidden treasure. St Michael's school – tradesmen's entrance – adjoins the old gatehouse to Tawstock Court. Still remarkably complete, it dates from 1546 and is all that remains of the Bourchier home of 1536.

The Bourchiers were Earls of Bath from the 15th century; one was appointed Lord Lieutenant of Devon a century later. Their name and that of the Wreys with whom the family later united to become Bourchier-Wrey appear among early rectors at St Peter's church.

The twin turrets and old studded door of Tawstock Court gatehouse survived a catastrophic fire in 1787 when the house was destroyed. Its successor, in new Gothic style, can best be seen by continuing down the lane; a wide façade with Gothic windows, castellated roof and typical 18th century terrace looks across sloping lawns used by the school for golf towards the river Taw and rising hills beyond. The school took it over in 1940 and has been there ever since.

Beyond on the left is St Peter's church, which is special even before you enter. Above the porch door is a sundial which records times for, among others, Cairo, Paris, Samarkand and Borneo. 'Watch and pray, Time steals away', says this unusual timepiece of 1757, made by Muddiford's John Berry. Only eight of these are known to have been made. Even signs of the zodiac, equator and tropics are included as it registers solar time, sixteen minutes later than Greenwich Mean Time.

I won't anticipate the pleasures of Tawstock's church for those who are drawn to visit. Suffice it that the tombs and memorials for Bourchiers and Wreys are amazing; there is a ringers' gallery in the north transept that bears examination and the family's square canopied and roofed pew nearby. On this basis, I'd love to have seen the original dwelling that accompanied the gatehouse.

16th century gatehouse to Tawstock Court.

TEIGNGRACE

—— I doubt whether the Templer family who owned Haytor quarry on Dartmoor would have expected to find themselves subjects of a heritage walk. The Templer Way Heritage Trail runs from Stover Country Park, once parklands for their home at Stover House (now an independent girls school), taking in the village of Teigngrace, an old railway line and the Stover Canal.

All three have strong connections with the family, who rebuilt Teigngrace village church. The railway line connected with Haytor granite tramway, constructed by Sir George Templer to ship ball clay and later granite down to the canal built for him by engineer Thomas Gray in the early 1790s and thence to the river Teign.

Walking the Heritage Trail can be undertaken in full or in sections – most are relatively easy going. If like me you are just curious to discover whether anything remains of the Templers' industrial heyday, there's an even easier way. On the A382 between Newton Abbot and Bovey Tracey – before reaching Teigngrace village itself – the road crosses a railway line and hump-backed bridge set close together. Buildings beside the level crossing are conversions of the old canal storage warehouses. Templer Way continues alongside the dried out canal bed; look over the humpy bridge to find remains of the canal basin's lining and girders among stumps of willow and the like sawn off recently.

The canal ran for two miles from Jetty Marsh at Newton Abbot inland to Ventiford; it was originally intended to carry on a further three and a half miles to Bovey Tracey itself. Coal, lime and sand were all shipped up-water on square-rigged sailing barges to avoid wasted journeys. At Ventiford and Locksbridge more remnants of the canal and its cargoes can still be seen – even if today it's a little short on water.

TEIGNMOUTH

—— Teignmouth seafront is enhanced by my favourite Devon pier, still a major attraction for visitors, although its ballroom and concert rooms were demolished in 1962 and steamers no longer call here. The pier was built in the 1860s at a cost of

around £8,000 to enhance a resort to which Brunel's atmospheric railway (see Starcross) ran 20 years earlier.

Teignmouth was already a fashionable watering place, considered suitable for invalids in search of sea air, when Tom Keats arrived in March 1818 with his brother John and took rooms at No 20 Northumberland Place, a double-fronted house just behind the seafront. The weather wasn't kind to poet John Keats and his ailing brother. Several inclement weeks induced him to describe Devon in a letter as a 'splashy, rainy, misty, snowy, foggy, muddy, slipshod county.' (Do say what you mean John, please!)

When the brothers arrived, Keats had already written much of *Endymion*: a poetic work in four 1,000-line sections. Perhaps it was the bad weather which allowed him to finish it in the three-storey house whose windows offered a view of the Teign and village of Shaldon opposite. He might also have found convivial company in one of several inns which Northumberland Place still boasts, of which the Jolly Sailor, where Catholics met secretly during times of persecution, is the oldest.

The sun must have shone sometimes; how else could Keats have penned verses about the area:

> 'For there's Bishop's Teign
> And King's Teign
> And Coomb at the clear Teign Head,
> Where close by the stream
> You may have your cream
> All spread on barley bread.'

In May 1818 Tom Keats was pronounced well enough to return home to London, brother John writing to reassure his former landlady Mrs Jeffrey at today's Keats House. This was far from the truth; Tom had consumption. After a short walking tour in the summer of the same year, John Keats nursed his brother through his last illness and continued to pour his emotions into some of his greatest works during the following year.

He had already taken the disease himself; by late 1820 he too left London – for Naples and Rome – in a last attempt to stave off the inevitable, to die in Rome early in 1821, aged only 26.

THURLESTONE AND BANTHAM

'Brave every shock, Like Thurlestone Rock' is the local saying in a parish that encompasses Bantham, Buckland and Thurlestone. Bantham is a lovely protected area of dunes near the mouth of the river Avon, where Evans Estates prohibit building on the banks or coastline. From May to October it's full of holidaymakers in boats, or 'resting' at the Old Sloop inn. Once a settlement in post-Roman times, you can catch a ferry across the Avon here while walking on the South West Coast Path.

To the south is Thurlestone. First impressions are of thatch in a pretty village street, an inn, hotel, post office, church and village cross. The cottages nearest the church comprised part of its old church house. Dropping through the valley, a golf course founded in 1897 behind the beach is very popular. Prince Edward (Edward VII) visited Thurlestone during his time at Dartmouth Royal Naval College to play here; a local story says he went to Thurlestone Hotel, built into a place of repute by the Grose family, for a cream tea. Here Edward was crowned in a mock ceremony – whether by waste paper basket or chamber pot depends on whom you ask.

Thurlestone Rock is a natural phenomenon around which stories have inevitably built up over the centuries. The name Thurlestone is thought to mean 'holed or pierced stone'; the famous Rock originated as a section of Devon old red sandstone, sited among clay and slate, resistant to erosion. The noise of winds and waves passing through it in storms are claimed to be heard five miles away in Kingsbridge; others say the whistling is a sure sign of an impending storm.

Thurlestone's sands are reached via a footpath and bridge, or by passing through the village and following country lanes to their furthest point. Whatever your choice, it's always bracing and the views are usually stunning along this stretch of coastal footpath. I've never heard Thurlestone Rock whistle yet, but I live in hopes.

TIVERTON

Not the driest place in the county, although this former market town in the rural heart of Devon made up for its weather

by the generosity of its wool merchants. They endowed three sets of almshouses; two have been restored and are still in use. Visit Greenway in Gold Street, near Loman Bridge, Slees or Widows almshouses in St Peters Street and Waldrons in Wellbrook Street on the west bank of the Exe. En route you'll embrace much of Tiverton's history.

A watery story is inevitable with two rivers and the nearby Grand Western Canal, opened in 1814 and restored for walkers and narrow-boat trips. In Fore Street, near Phoenix Lane a constant supply of water bubbles up through a central stone. This is Coggan's Well: the termination of a town leat given to Tiverton in 1250 by Isabella, first wife of Hugh de Courtenay, Earl of Devon (whose family owned Tiverton Castle).

The leat, originating at the head of a stream on Norwood Common, was diverted through the town to supply its citizens with a clean water supply. Every seven years it is still 'perambulated' in an ancient custom of water bailing. You can follow part of its course from Fore Street, where it disappears up an alley towards the market. Pick it up again in Castle Street, with small bridges across in the centre of the road. A final, more robust bridge leads to the castle through Hit and Miss Alley, which once opened into Tiverton Castle tiltyard.

At every point of proclamation the procession of four Pioneers, Bailiff, schoolboys (usually from Tiverton public school) with withy wands, Town Crier, Beadle, Mayor and any interested townsfolk stops for what is now a token inspection of the leat. Photographs of past years in Tiverton Museum show that watery horseplay was one of the chief attractions of this formerly serious ceremony, ending with sports and refreshments at Norwood Common.

Coggan's Well is also the focal point for proclaiming Tiverton's ancient charter fairs in June and October; nowadays the most exciting part is a penny scramble for children. Coggan, sometimes Cogan, was Isabella's family name, associated with several nearby manors. What better tribute for another early Tiverton benefactor than to name the town's central well after her.

TOPSHAM

—— Correctly pronounced Tops-ham – named after Toppa – this near neighbour of mine's a personal favourite. It has typical

port-like streets, overhanging upper storeys and converted nail cellars, rope lockers or merchant warehouses, plus fabled Dutch houses on the Strand. These were built from small clinker bricks brought from the Low Countries as ships' ballast by generations of merchants. Topsham's architecture is matched by views of the tidal river Exe to the sea, across the Exeter Canal and upriver to Exeter Cathedral's twin towers.

Romans used Topsham as their port for Isca Dumnoniorum (Exeter); a straight three mile stretch of Topsham Road towards the city of which it is now part is a clue to this fact. So much of Topsham is the stuff of tourist guidebooks it was difficult to select a 'hidden' aspect.

In Topsham's Fore Street (there are lots of these in Devon) stands the Salutation Inn, a coaching post dating from 1720, later having the town's assembly room above its projecting porch and a bowling green at the rear. Here too wrestling bouts were held, especially during Topsham's late August fair.

Enter its rear bar, and experience the world of Topsham's town criers. Jon Reed is the current office holder; his predecessor Douglas Fletcher who died in 2001 was in the post for 26 years. He instigated an international town crier contest for Topsham, growing in strength yearly from 1989. Around the bar walls is photographic evidence in plenty. If you are lucky and visit Topsham when some special event is taking place you may see – and especially hear – Jon at work.

I daren't omit Topsham's importance in the world of bird watching and twitching – don't tell the former that both are the same! Visit Goat Walk, along the riverside beyond the Strand, so named because when built famous resident Sir Alex Hamilton complained it was 'scarcely wide enough for a goat to walk', and watch wading birds or admire views to the plateau of Great Haldon. By following the lane beyond Goat Walk at Riversmeet, Bowling Green marshes are reached, where a renowned public bird hide records sightings. You'll usually find someone on hand to identify an unknown bird. Recommended – at all seasons.

TORQUAY: BABBACOMBE AND PETITOR

One of the reasons Torquay emerged as a popular seaside resort must have been its plethora of beaches – many only

discovered when the town 'overflowed' during the 19th century into surrounding ancient parishes.

Queen Victoria loved Babbacombe; she came as princess, returned in 1846 and brought Prince Albert to admire panoramic views along the East Devon coast into West Dorset. Her girlhood friend and former lady in waiting Mrs Whitehead lived in Babbacombe Glen; hence another royal visit to see her in 1852.

Babbacombe's theatre is well patronised by visitors; so is the cliff railway built in 1925 between Babbacombe beach and Oddicombe. A comprehensive model village brings coachloads of holidaymakers here daily. It's best seen illuminated on summer evenings.

Strolling on Babbacombe Downs was a fashionable way of passing the time in Victorian times – an activity which has its equivalent today in walking the coastal path from here to Petitor beach, where a concrete bathing platform reminds us that bathing here was once designated for gentlemen only and where late 18th century traveller Rev John Swete mentions marble quarrying and working taking place.

Among those making their home at Babbacombe were the Mount-Temples, who lived at the top of Beach Road in what became Babbacombe Cliff Hotel, built for Lord Mount-Temple (the Liberal MP William Cowper) in 1878 by W. E. Nesfield. Baroness Georgina is commemorated for her many philanthropic acts by an attractive fountain at the Oddicombe end of Babbacombe Downs, erected in 1903. The figure in wide-sleeved dress and mob cap usually has a spray of fresh flowers or shrubs in her right hand. On the left wrist rests a bird – possibly a symbolic dove – but more likely recognising her support of the RSPCA and anti-vivisection issues. The Mount-Temples were also Pre-Raphaelites. When Georgina died in 1901 the *Manchester Guardian* described her beauty as almost faultless, and praised her passion against injustice and help for the downtrodden.

Georgina Mount-Temple's former home has literary connections. Oscar Wilde, who was distantly related, leased her house for three months in the 1890s. Here he finished writing *A Woman of No Importance*, attending rehearsals for *Lady Windermere's Fan* in Torquay itself before its opening in 1893. Edgar Wallace also wrote many of his novels in the hotel, and in nearby Paignton.

TOTNES

'Hippies' heaven', someone once told me, describing Totnes : 'leylines, Buddhists, medieval leechwells and all that sort of thing.'

The Dart river port was claimed by Geoffrey of Monmouth in the 12th century as the birthplace of our British people. Brutus the Trojan, the story says, landed at Totnes having sailed up the Dart. 'Here I stand and here I rest, and this place shall be called Totnes' is the legend accompanying an obviously ancient stone beside No 51 Fore Street. The one Brutus stepped ashore on? I somehow doubt it. An obelisk outside the Seven Stars Inn celebrating William Will, who pioneered crossing Australia between 1860 and 1861, has more credibility.

What do the 21st century's New Agers here make of the computer era – and what would Babbage, father of computers, have made of them? Charles Babbage, grandson of a 1754 mayor of Totnes, was born in London but soon brought back to Devon where he belonged to attend Totnes Grammar School, located behind Fore and High Streets next to the old Guildhall.

In 1810 Charles won a place at Cambridge University where his mathematical brain often surpassed those of his professors. Cowcatchers for trains in the USA were an example of his inventive qualities; in conjunction with Isambard Kingdom Brunel he produced a speed recorder, which foreran today's 'black box'.

In an attempt to create a machine to ease the problem of producing accurate logarithm tables for navigators and surveyors, Babbage made a model 'difference engine' in 1822 capable of calculating to twenty decimal places. By 1842 when he abandoned the idea Charles had adapted punch cards used for looms to design an 'analytical engine'. This, believe it or not, was the father of our modern computer.

Did he make one? No, but his drawings and notes allowed someone else to follow them – and it worked! You can find it in the Science Museum, but if London is too far away, Totnes Museum has a Babbage room in its lovely Elizabethan building at No 70 Fore Street: once the home of a Totnes merchant adventurer.

UFFCULME

The River Culm, on which Uffa once had his farm or settlement, is alternatively named for a 'knot' or 'loop' – a good way to describe the Culm's winding nature. We are once again in wool country in a parish where markets were part of the secret of its wealth. There was no manor house here because it was held by a succession of absentee landlords.

Uffculme's now famous Coldharbour Mill, founded by the Quaker Fox family in 1798 and still working in 1981, is better known today for its regular 'steam' days – when they power up the boilers – and its working wool museum. Thomas Fox built the present three-storey mill, and houses nearby out of concern for the workers' welfare. It seems no coincidence that at nearby Spicelands there is a Quaker meeting house beside Five Fords.

Uffculme is still a lively village, with an old style butcher's, post office and shops, including one selling trail bikes – quite an asset given the many tracks in the area – an inn and a large feed mill. In the Square is what at first glance looks like a lychgate that has somehow divorced itself from the church of St Mary the Virgin down the hill. It is actually one of Devon's few remaining shambles, 17th century or earlier, measuring only thirteen feet by nine; the open timber structure has carved bargeboards and a pitched slate roof.

There can surely only have been enough space for one butcher to ply his trade here, unlike other shambles in Devon including one at Honiton which once blocked the centre of the road. The counter where freshly-slaughtered meat was offered for sale – if you didn't mind treading in the aftermath – has been replaced by a double wooden seat, making it a pleasant spot to sit and watch the world go by. Somebody had the sense to restore the little building, which was in use until markets ceased here in 1914 although largely abandoned once a butcher's shop opened in the village.

UGBOROUGH

Best Kept Village several times in the 1980s and 1990s, with a recent South Hams environmental award, Ugborough is built around a traditional square. The village church of St Peter,

dating back to 1121, stands on a rise inside an early earthwork at the top; its 94 foot red sandstone tower looks even higher as a result. Seen from the road between Modbury and Kingsbridge the whole place gives an impression of standing proud of the surrounding countryside.

St Peter's is worth a visit if only for its 32 panelled screens, many claimed to be original. The panels depict characters from the nativity, Christ's crucifixion, including implements and instruments of torture, and one or two apparent 'misfits' like a man in Tudor dress.

On one side of Ugborough's Square, used for parking, is a feature with 'VR 1887' on its side. A square built conduit, with stone reinforced corners each topped by a roof pillar and ball, ends in a domed roof, ball and lamp. 'This conduit was erected

Rood screen detail, St Peter's church.

in 1887 to commemorate Queen Victoria's Golden Jubilee and served as the water supply to the village', reads a plaque on it. Signs of the old spout can be found below a shield; another side is taken up by a tablet commemorating Queen Elizabeth's coronation in 1953.

Ugborough's conduit has echoes of Adrian Swete's much earlier version in Modbury. Bearing in mind that Modbury might well have been Ugborough villagers' 'big town', this may well explain why they decided to put in a conduit as tribute to a well-loved monarch.

There is still a post office and stores in the Square, close to a building which informative locals say was a Brethren chapel. Unusual in a small village? Something else I've noticed in this part of Devon is that 'minor' sects seem to have been quite popular.

Roads lead towards Plymouth via Ermington, South Brent, Totnes and Bittaford from the Square at Ugborough – which still has two flourishing inns and some stylish barn conversions. All in all, not a bad spot to live.

UMBERLEIGH

——— Athelstan owned much land in this area; Umberleigh probably also had his palace in AD 936. The village, which straddles the A377, has links to the Bassett family. They took over Umberleigh Barton, now a farmhouse on the main road towards Barnstaple whose wall is supposed to contain a toothmark impression from John of Gaunt. This was said to be his way of signing the grant of Barton Fee. A piece of doggerel accompanies the story:

> I John of Gaunt do hereby give
> To thee and thine, from me and mine
> The barton fee of Umberlee.
> And so the world may know its truth
> I hereby seal it with my tooth.

I didn't have the nerve to burst through the gates and examine the stonework in minute detail. Comedian Eric Morecambe would have had no such qualms, had the Rising Sun's landlord

told him this tale. Eric, known as a passionate fisherman, is pictured twice in the montage of personalities and their catches inside the Rising Sun's bar. In one he is dressed to fish, in action on the Taw's banks. The second is typical 'showman Eric'; he is holding a massive catch – a dummy fish which came from the inn's sign!

Trout and salmon fishing and the Taw go together here in Henry Williamson country, setting for *Salar the Salmon*. Beside the Rising Sun's hotel entrance is a board on which names and details of catches can be recorded, to enhance that photo of you and your fish.

Umberleigh, like most of the Taw valley, was also famous for growing Mazzard Green cherries (see Atherington). It has kept its railway station, although the market gardens and orchards have largely gone. On Barnstaple market day it's not unusual to see passengers boarding with goods to sell there. En route to the station is a small wooden building painted in maroon and cream, with a cross on its roof. On enquiry I discovered this is the church of the Good Shepherd, built in 1874 by Rev Trefusis on land owned by the Great Western Railway, who decreed it must be painted in their colours. Unfortunately it was locked; services only take place every couple of weeks.

WEARE GIFFARD

—— Henry Williamson sited the birthplace of *Tarka the Otter* in a holt under Canal Bridge on the river Torridge just south of here; Tarka's commemorated on a beautiful village sign as you wend your way along the three mile ribbon of houses on the river's east bank, approached by a wooded valley. The river meanders among meadows: sometimes hugging the road, then leaving it stranded.

Weare Giffard has a fascinating history, once boasting a shipyard and quay, limekilns, two mills and a thriving trade in pottery clay. Lord Rolle's canal ran from here to Okehampton from 1824 to c1871, joining the Torridge at its highest navigable point. Not so today; this is a village where strawberry growing is no more, or cider orchards – and not a great deal of farming remains either. Houses and cottages show every sign of having gone upmarket.

Halfway through the village close to Holy Trinity church is Weare Giffard Hall. Giffards and Fortescues (who became Clintons – and later Rolles) once lived here; today it's a 15th century manor house with 1832 restorations by George Matthew Fortescue following neglect in the 17th century. Martin Fortescue began the present building, including a hammer-beamed roof in the Great Hall. When he died in 1472 son John had it completed. A 13th century Giffard – Sir Walter, who went on crusade – has his effigy and that of his wife in Holy Trinity church; so does Hugh Fortescue, kneeling facing his wife, with son John and wife Maria.

Although the Hall is a private house, the owners don't seem to object to visitors peering through the gateway, to spot another gem of Devon's past. If you follow part of the Tarka Trail and cross the Torridge at Canal Bridge, there's an even better view of it from the opposite riverbank. Isolated close to the water stands a battlemented 16th century gatehouse which once had an outer courtyard wall attached. Alas, during the Civil War its occupants were 'on the wrong side' for these parts and all but the gatehouse was removed to prevent further resistance. The original door still has a grid of rectangular lozenge panels, displaying lions in the upper part; straight-headed windows are classic 16th century.

WELCOMBE

Another place (see **Hartland**) where we encounter St Nectan. The name Welcombe means spring-valley, the spring almost certainly feeds St Nectan's or Holy Well.

A neat hut of stone with a ridged roof sits on the left at the top of a lane leading eventually to Welcombe Mouth, beside a triangle of land near the churchyard. Yes, the church is also named after St Nectan. It was a medieval chapel for Hartland Abbey, given parish status and enlarged by adding transepts.

The well looks horribly stagnant; tongued ferns flourish inside. An icon card of St Nectan, passe-partout framed for protection against the elements, sits in the niche where doubtless an image once rested. As I examined it, I too was under scrutiny from an elderly local and his dog. The latter gave the impression I'd prevented him investigating a favourite sniffing – or leg-lifting spot. His master informed me that the church was

unlocked but 'everything is coded'. How not to make people welcom(b)e!

Inside, I gleaned that St Nectan's Welcombe has famous bellringers, in the Tamar Valley Guild. They have six bells, one cast in 1731. The church also has a Devil's Door on its north side, which by superstition should be opened at every baptism when the lines 'renounce the devil and all his works' are reached, for the escape of the fiend. 'At every other time', said the Rev Hawker, curate in charge for many years in more superstitious times, 'it should be carefully closed.'

Perhaps a sprinkling of St Nectan's holy water or an hour's quiet contemplation of spectacular interlocking green spurs of the combe with an Atlantic backdrop would be equally effective in banishing impure thoughts. There's not much at Welcombe nowadays to tempt the devil, even in his most rapacious mood – unless you include its wild coastal scenery.

WESTWARD HO!

—— Westward Ho! is almost entirely modern – in Devonian terms. Development only followed the publication of Charles Kingsley's novel of the same name in 1855, at which time Devon's seaside resorts happened to be in the ascendant. It has the distinction of being the one place in this country to be named after a novel and to have an exclamation mark at its end.

One hotel and some scattered villas, a line of shops and Holy Trinity church – its description in 1872 – have given way today to caravan parks, amusements and surf hire behind the resort's two miles of sands and landmark pebble ridge.

They have strange customs here too; pot walloping as most of us understand it is the right to vote – or establish some other claim relating to property or land – by boiling a pot on your own fireplace. At Westward Ho! it is part of a communal festival when everyone dresses up and flings pebbles which have fallen during winter storms back onto the ridge.

Goodness knows what Rudyard Kipling would make of today's hotch-potch of buildings and activities. He came here in 1878 to attend the United Services College from India, at the age of 12; headmaster Cornell Price was a family friend. The research for his book *Stalky & Co* was garnered here. Kipling dedicated it to Mr

Price, having left Westward Ho! in 1882 to take up a post with a Lahore military newspaper, and continued writing thereafter.

Kipling Terrace marks the site of the United Services College: a long, white painted, elevated run of houses alongside Kingsley Road (literary neighbours in more ways than one). It lies just below tors also named after Rudyard Kipling; his favourite escape spot when smitten with home-sickness. Now gorse-covered, they are under National Trust protection.

Kipling might have tolerated one Westward Ho! pastime, laid out on its burrows by 'old Tom Morris'. The Royal North Devon Golf course is the oldest links course in England. It may be flat, but there are enough natural and man-made hazards to challenge any player. Should you decide to investigate the Country Park salt marsh and sand dunes, be prepared for an occasional stray golf ball.

WIDECOMBE

It's virtually impossible to escape the Uncle Tom Cobley factor at Widecombe (if you want to, that is), within the village itself and its gift shops, eating places and the once-a-year mayhem that marks Widecombe Fair each second Tuesday in September.

Turning left in front of the former church house, now village hall and National Trust shop, make for the Rugglestone Inn. Assuming you can resist the temptation to sit in the garden and enjoy a glass of cider, continue up the lane which leads to Higher Venton Farm and Buckland to the former, once the home of the legendary Beatrice Chase.

Beatrice, real name Olive Parr, claimed descent from Catherine, sixth and last wife of Henry VIII. She wrote, was a friend to prisoners in Princetown Jail and to soldiers in the First World War, and was considered eccentric. Beatrice/Olive moved here at the beginning of the 20th century, living as a practising Roman Catholic and writing books and poems about Dartmoor. Behind Venton, looking rather like a garage or storeroom with its corrugated roof and green painted window frames, is the former chapel she shared with passers-by. Two clues to its past life are the small stone cross on its roof and stained glass in some windows.

Beatrice Chase is credited with being the first to place fresh flowers secretly on Kitty Jay's grave beside the road at Hound Tor two miles away. The presence of the flowers marking the burial site of a workhouse girl who committed suicide after being seduced by her employer's son became one of Dartmoor's mysteries, especially as the flowers continued to arrive after Beatrice's death in 1955.

The grave of Olive Katharine (or Catherine) Parr, alias Beatrice Chase, is in Widecombe's St Pancras churchyard. Its presence contravenes her wishes; she left orders that her body, clothed in her Dominican habit, should be interred without coffin at the top of a field, with her 'three little cats'.

If you pay Beatrice Chase's chapel a visit and have the courage to continue beyond Higher Venton through narrow lanes, climb onto Pudsham Down and turn towards Haytor and Bickington to enjoy spectacular moorland views.

WINKLEIGH

What a lovely, pompous pump! Winkleigh's an interesting village on a hill rising from rolling countryside in mid-Devon, which once boasted a castle at each end, representing its two 12th century manors: Wynkelegh Keynes and Wynkelegh Tracey.

Court Castle, just off the B3220 which, with the road into the village, effectively splits the site, has a 17th–18th century house on the former bailey, and a folly where the keep once stood. Croft Castle's mound can be clearly seen at the bottom of Castle Street; Winkleigh's village hall occupies part of the area. Both were almost certainly fortified manor houses. There's an attractive thatched 17th century Kings Arms inn, lots of white houses lining tiny streets, a post office and two shops, a school (with original bell), a vet's surgery, a small garage, All Saints' church – and the pump.

It rises on a four-sided base with an elongated pyramid. Villagers were very grateful for its arrival in 1832, allowing them to collect water more conveniently – especially as it was never known to run dry. The conduit and pump are sited over a well big enough at the bottom to turn round a horse and cart. Winkleigh's inhabitants still have the well blessed at the start of

their lively fairs week in June (less as a precaution against drought nowadays).

This village pump commemorates the Parliamentary Reform Act of 1832; faded carving on all four sides names King William IV, the lords Gray, Brougham, Russell, together with Althorp – all of whom were involved in passing the Act. Its long pump handle and front spout have been preserved during a 1994 renovation to celebrate Winkleigh Parish Council's centenary. A drain and trough in front, together with a locked wooden door at the back, suggest that, should other systems fail, Winkleigh might still have a useful water supply below its wide main street.

Something the inhabitants of Vine House, just off Fore Street also enjoy. Outside are two pumps and an old millstone. One of the former has been fitted with a stop tap, so it may still be contributing to the splendid floral displays in the narrow front garden. No wonder Winkleigh enters the *North Devon Alphabet of Parishes* as 'P is for Pump'.

WITHYCOMBE RALEIGH

When does a village cease to be a village? Perhaps when, like Withycombe, it becomes absorbed into a larger neighbour, in this case Exmouth. People hereabouts still talk of 'popping into the village'; two old inns and some thatched cottages perpetuate the image.

Withycombe Claville was one of two important manors while Exmouth was only a 'fisschar tounlet' (Leland), held with a fee of providing the king with two good arrows stuck in an 'oaken cake'. A Saxon church stood here even before William de Claville built his manor house, sub-let from 1273 to Sir Hugh Raleghe and his descendants. Today's village – named Withycombe Raleigh after Sir Walter's family – has the church of St John the Evangelist in its heart. The ancient tower of Withycombe's original church rises among yew trees over a mile away, bearing the evocative name of St John in the Wilderness.

St John in the Wilderness has a 14th century tower; a pillar from 15th century arches among those preserved in the north aisle bears a green man sculpture and Tudor rose carving. The font has '911' scratched on its base; someone later in history undoubtedly faked it!

There were three bells in the tower until around 1790 when two were sold to an Exeter ironmonger for £74 18s 6d, leaving only Pennington Bell dated 1655. The money helped repair the north aisle of St John the Baptist (its earlier name); the south aisle was demolished in 1788. Bells like these, said to have received papal blessing, were believed capable of ringing for the death of their feudal lord without human assistance – which they did according to a legend of rivalry between lords of the neighbouring manors of Withycombe and Littleham.

The story introduces an 'Indian weed', smoked in long tubes to scare away a ghost. Was Sir Walter, whose Drake cousins (relatives of Sir Francis) owned Bystock within Withycombe until 1712, really so influenced by the tale that he went in search of this weed to bring it to England as tobacco? Doubtful; there are, however, monuments within St John in the Wilderness – so renamed in the 17th century for its remote situation – confirming association with both Drake and Raleigh families.

It is worth diverting into the 'wilderness' to visit.

YARCOMBE

——— I visited Yarcombe after hearing a speaker on the Battle of the Nile, expecting to find a plaque at Yarcombe Inn saying 'Nelson visited here 1801'. Such expectations are often doomed to disappointment – and they were in this instance. Nobody there had ever heard of the event.

They were able to show me round a very old inn, formerly the Angel and once a 14th century priory gatehouse for Otterton Priory, making it a church house. The manor of Yarcombe was owned by Sir Francis Drake; I discovered this fact in St Michael's church. Now Sheafhayne Manor, he acquired a half interest in it from Richard Drake of Ashe and later petitioned Queen Elizabeth for the other half. In consequence villagers can claim they had one of Devon's most famous sons as their landlord. He would also have owned the church house, which was the Angel Inn by 1754, and changed its name again to Yarcombe Inn in 1818, after extensions for stagecoach passengers on the route west to Exeter had been made.

I didn't intend to let Nelson's connections go without a struggle; in researching one of the famous admiral's captains –

George Blagdon Westcott, who came from nearby Honiton – it became clear that a story concerning Nelson, Westcott's mother and a campaign medal had some substance. On 17th January 1801 Nelson wrote to Lady Hamilton that Westcott's mother was in 'low circumstances, except for the bounty of government and Lloyds', after paying a brief visit to Honiton. Here he met Westcott's mother and sister, following the Captain's death at the Battle of the Nile in 1798, at the Golden Lion. Learning Mrs Westcott had never received the gold service medal due to her son, Nelson is understood to have removed his own Nile medal and apologised for its being 'secondhand'.

On the basis that the route back to Portsmouth would have taken Nelson through Yarcombe, it's quite likely he stayed at its inn – especially if he knew of its connection with that other great mariner: Drake. I'd still love to know what happened to the plaque.

YEALMPTON

'Old Mother Hubbard, she went to the cupboard ...' The shortage of food in this well-known nursery rhyme is thought to have referred to scarcities during the Napoleonic Wars.

Sarah Catherine Martin (sometimes called Sarah Oliver), daughter of the resident commissioner of the Royal Navy, was staying at Kitley House in Yealmpton with Edmund Polloxfen Bastard and her sister – his second wife Judith Ann – when she wrote the 28 verses. These encompassed local shops and inns of around 1800. Mother Hubbard herself is assumed to have been the housekeeper at Kitley, who retired to a thatched cottage in the village centre, now dignified with her name and ornamented with a small dog on its thatched roof. The cupboard will hopefully not be bare should you call; its most recent use is as a restaurant.

Only one copy was originally printed of *The Comic Adventures of Old Mother Hubbard and her Dog*, by a London publisher John Harris in 1805. It was given to Edmund Bastard as a birthday present, having been written to amuse his children. Within a year Harris obtained permission to make an edition of 10,000 copies.

Kitley House is now a hotel and restaurant, beautifully situated close to Yealmpton in 300 acres, with lake and river,

Old Mother Hubbard's cottage, complete with dog on roof.

where Bastards and Polloxfens have lived since the 16th century – or even earlier. Its remodelling took place in 1820, by George Stanley Repton, incorporating 'a Georgianised Elizabethan mansion'. Bastards are presumed to have arrived in this country with William the Conqueror and Robert the Bastard appears in Devon's Domesday records holding several manors. An Anne Polloxfen married William Bastard c1710. We also know that John Polloxfen Bastard of Kitley was son to a William Bastard who saved Plymouth's arsenal in 1779 from a French raid and who was Member of Parliament for Truro.

And Sarah Catherine – the creator of Mother Hubbard? She was an early love of William IV before he succeeded to the throne of England; had she accepted his proposal when she was a mere 17 years old and had she gone on to have his children, Yealmpton – and Devon – might have had a hand in changing the course of history.

INDEX